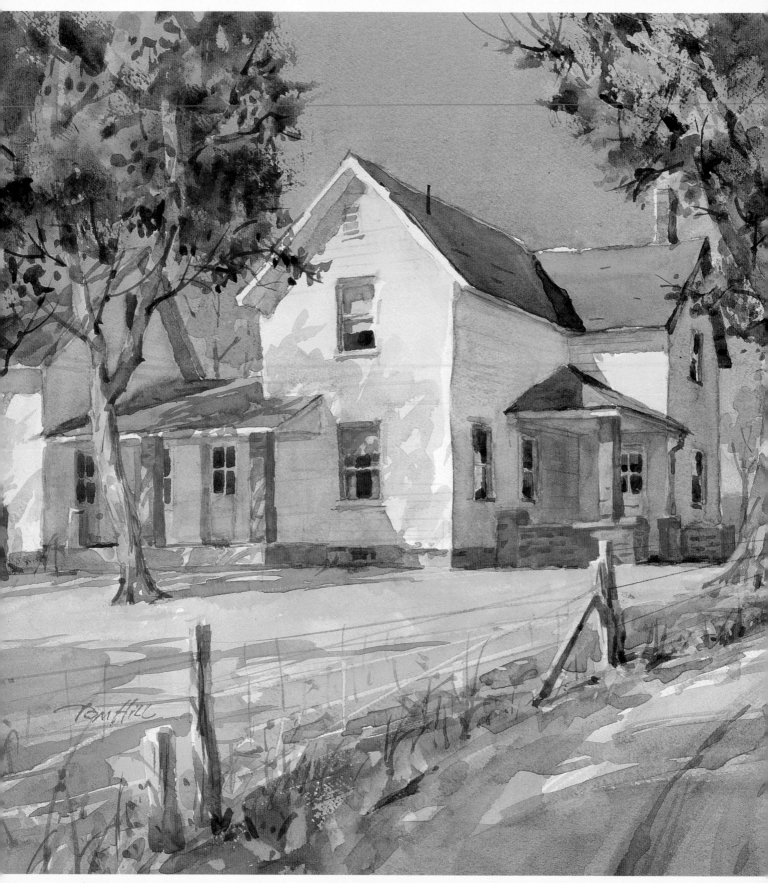

▲ FARMHOUSE ON THE HILL 13″ × 18½″

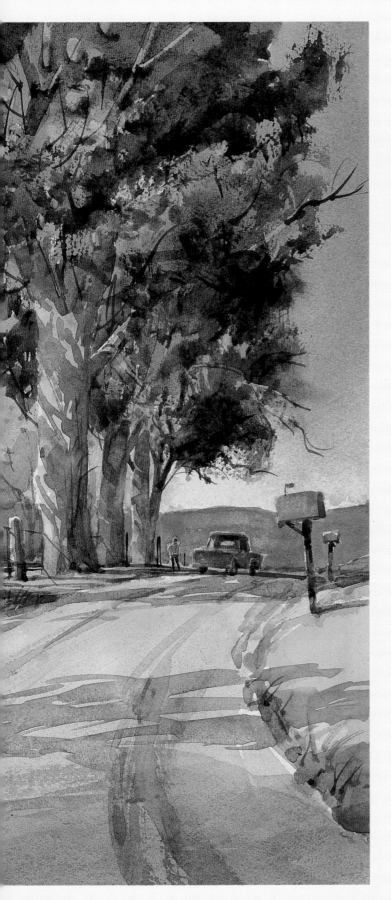

Painting
Watercolors
On Location
with Tom Hill

NORTH LIGHT BOOKS
CINCINNATI, OHIO

About the Author

Tom Hill grew up in Southern California, was a scholarship student at the Art Center College of Design there and later continued art studies at the Art Institute of Chicago. He has had a most varied art career: a Navy artist while in the service; a storyboard and set design artist at Universal Studios in Hollywood; an artist-reporter for the *Chicago Tribune*; and an illustrator and graphic designer freelancing in New York City before moving to Arizona, where he now lives and pursues a full-time fine art career.

Travel and art assignments have taken Tom to more than 40 countries around the world. He is the author of several best-selling books on watercolor painting, including *Color for the Watercolor Painter*,

The Watercolor Painter's Problem Book, The Watercolorist's Complete Guide to Color, as well as a number of articles in various art journals. He is an elected member of the American Watercolor Society and the National Academy of Design. He also holds honorary membership in several Western watercolor societies.

He has exhibited in many one-man and juried shows across the nation, including such places as the Academy of the Arts, Honolulu; the Los Angeles Artists' Association; the Art Institute of Chicago; the National Academy Galleries in New York; the Gilcrease Museum in Tulsa; and the National Cowboy Hall of Fame in Oklahoma City.

Painting Watercolors on Location with Tom Hill. Copyright © 1996 by Tom Hill. Printed and bound in China. All rights reserved. No part of this book may be reproduced in any form or by any electronic or mechanical means including information storage and retrieval systems without permission in writing from the publisher, except by a reviewer, who may quote brief passages in a review. Published by North Light Books, an imprint of F&W Publications, Inc., 1507 Dana Avenue, Cincinnati, Ohio 45207. (800) 289-0963. First edition.

Other fine North Light Books are available from your local bookstore, art supply store or direct from the publisher.

00 99 98 97 96 5 4 3 2 1

Library of Congress Cataloging-in-Publication Data

Hill, Tom.
 Painting watercolors on location with Tom Hill / Tom Hill.
 p. cm.
 Includes index.
 ISBN 0-89134-634-1 (alk. paper)
 1. Plein-air painting—Technique. 2. Watercolor painting—Technique. I. Title
ND2365.H55 1996
751.42′2—dc20
 95-51802
 CIP

Edited by Kathy Kipp
Designed by Angela Lennert Wilcox

North Light Books are available for sales promotions, premiums and fund-raising use. Special editions or book excerpts can also be created to specification. For details contact: Special Sales Manager, F&W Publications, 1507 Dana Avenue, Cincinnati, Ohio 45207.

To Barbara

To my editor, Greg Albert, to David Lewis,
Kathy Kipp, Katie Carroll, Angela Lennert Wilcox
and all the other folks at North Light Books
who helped put this book together.

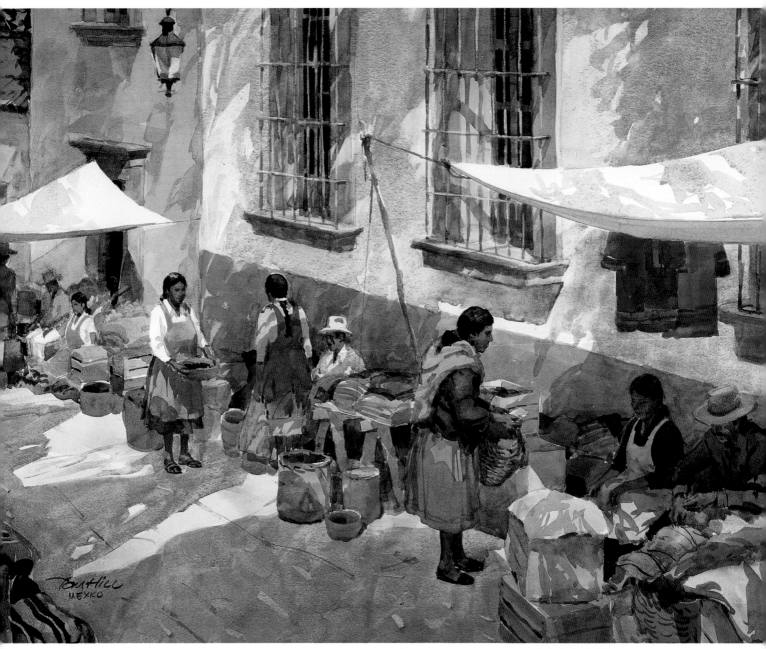

▲ SIDEWALK MARKET, SAN MIGUEL 21″ × 28½″

Table of Contents

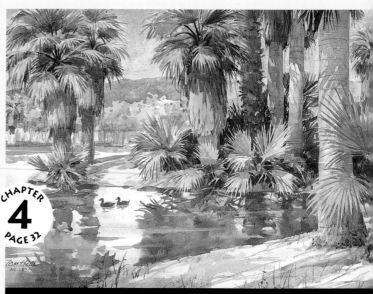

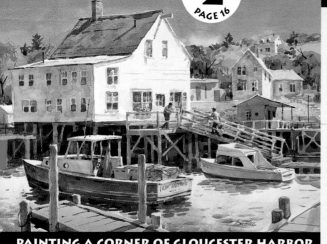

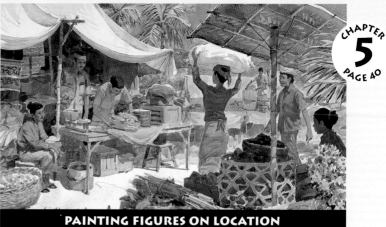

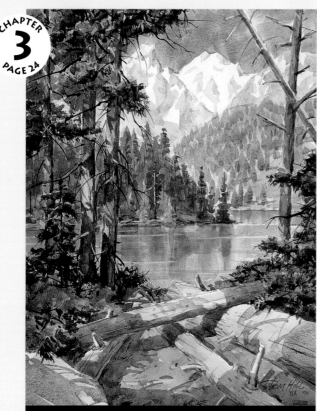

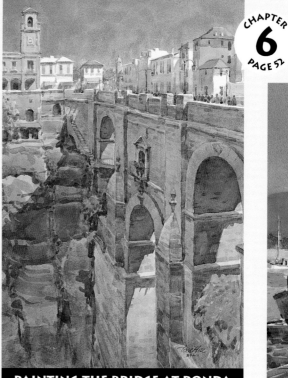

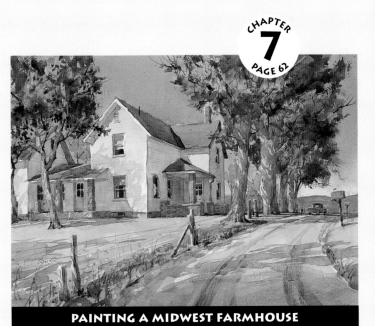

PAINTING A MIDWEST FARMHOUSE

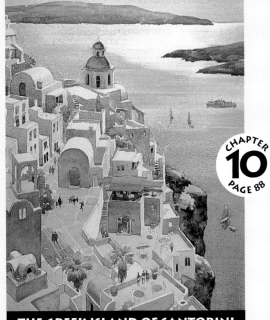

THE GREEK ISLAND OF SANTORINI

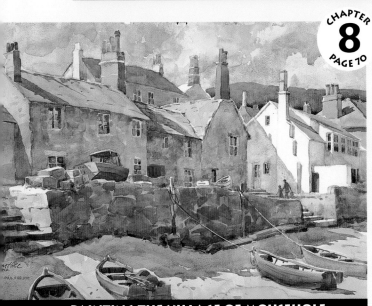

PAINTING THE VILLAGE OF MOUSEHOLE

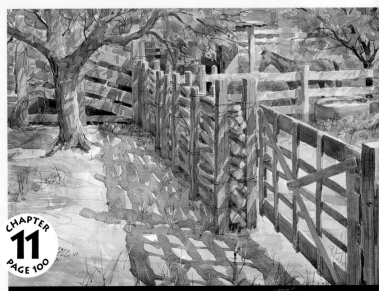

OLD WESTERN CORRAL

PAINTING EARLY MORNING LIGHT AT HANIA

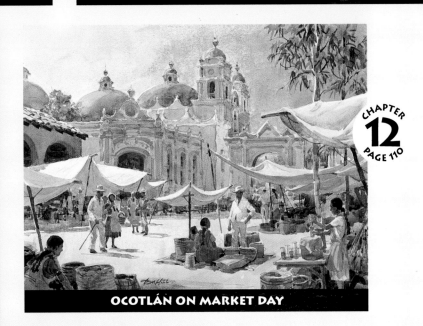

OCOTLÁN ON MARKET DAY

▲ ALONG THE AMALFI COAST 21″×14″

WHY PAINT ON LOCATION?

Painting directly from the subject isn't a new idea—artists have been doing so for centuries. Everyone has an image in his or her mind of the artist working from a live model, a still life, or a scene. We all know that the artists of the Renaissance—and probably long before that—used models and props in their studios to be able to understand and accurately paint what they had in mind. Painting out-of-doors, right on location, seems to have flowered with the Impressionists in the 1800s and has continued right on up to today.

Still, people will ask: "Why go to all the trouble to paint on location, when it's so much more comfortable at home or in the studio? Why put up with all that business of carrying gear to the location, contending with wind, bugs, onlookers, no handy bathroom, constantly changing sunlight, etc.?"

My answer is that, of course, we all do a lot of painting in our studios. I use my memory, sketches, notes and photos to help me understand my subject and try to produce better paintings. But, you're just going to get more out of your subject by having the *real* thing to work from! Something about that subject attracted you in the first place and inspired you to want to make a painting based on it. So why not stay right there with that inspiration, where everything you need to know is right in front of you? It might be a bit more trouble, but there's no substitute for it. I highly recommend that you add "on location" painting to your routine. Your work will have more conviction and speak with authenticity, and you'll grow more rapidly into that better artist we all aspire to become!

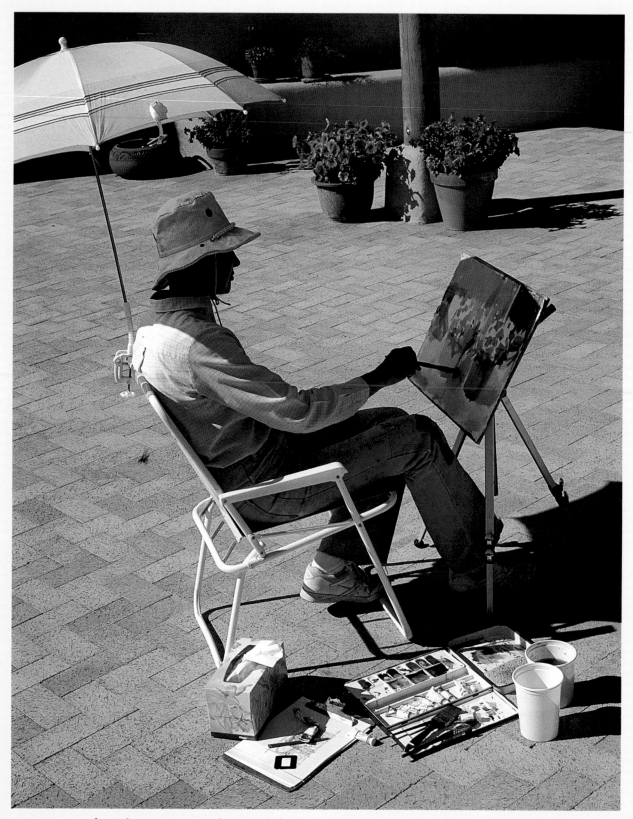

▲ Here's my wife, Barbara, painting on location. What a great, direct way to get inspiration *and* information all at once! To those of you who hesitate to paint outdoors: This may not be quite as comfortable as indoors but it's pretty nice! The semi-transparent umbrella cloth is white, so it stops the glare of direct sunshine, but lets a nice, soft light through and doesn't add any unwanted color to the watercolor paper surface. (The passing bee you can see behind the chair didn't sting—it just flew on by!)

GET READY TO PAINT . . . ON LOCATION!

Your indoor painting spot or studio can be anything from a corner of the kitchen table to an elaborate, specially designed studio building, with every feature and comfort an artist could wish for. Your *outdoor* "studio" can also run the gamut from minimal to elaborate. The big difference is that it must be *mobile*—you have to be able to take it to the painting location!

What equipment does one need to be able to go out and paint successfully at the site? As with so many other choices in life, it all depends.

At the very least, you could have a small watercolor pan set (like you had back in grade school), a little watercolor paper tablet, a brush and a small bottle of water. It's possible it could all fit into your jacket pocket or your purse! It's also possible that travelling this lightly, you might have to sit on the ground and hold your painting in your lap. A good painting result is still obtainable, even with this small amount of painting equipment.

At the other end of the scale, you might have a large truck, van or trailer, wherein you could carry nearly as many painting amenities as you'd have in a home studio, and could paint while inside this vehicle, away from bugs, weather, onlookers, etc. Most of us, I suspect, will want a mobile "studio" somewhere between these two extremes.

In general, your on-location setups will depend on your way of working, where your painting spot is located, and how much time and resources you have available.

A WORD ABOUT MATERIALS

This book is concerned with painting directly from the subject—how to manage this type of painting and succeed at it—and does not delve too deeply into watercolor painting techniques. There are many fine books devoted to techniques, so there is no need to cover that subject here. However, I do want to talk about the materials that I use most often, especially for on-location watercolor painting.

WATERCOLOR PAINT

I prefer moist tube colors to the harder ones in block or pan form. I find them easier to load on the brush, easier to control. My choice of hues is related to the solar spectrum—the colors you see in a rainbow: red, orange, yellow, green, blue and violet. As artists' colors don't quite match the solar ones, I get as close as I can, with a "cool" and "warm" version of each.

- Reds: Scarlet Lake (warm), Alizarin Crimson, Permanent Rose (cool).
- Oranges: mixed from yellows and reds, Burnt Sienna (grayed red-orange).
- Yellows: Lemon or Hansa (cool), New Gamboge (warm), Raw Sienna (grayed middle).

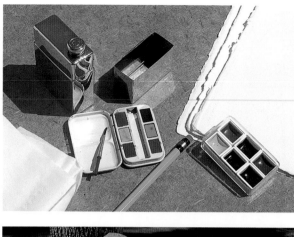

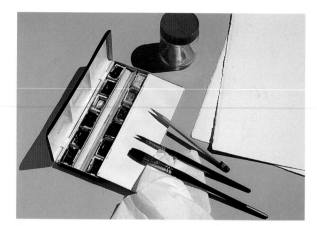

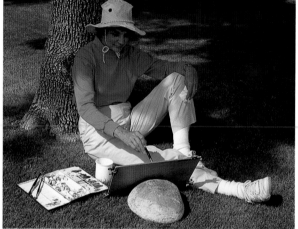

▲ The two photos above show how very small watercolor essentials can be! The ordinary pencil gives an idea of scale. Several manufacturers make these little pan watercolor sets. In a situation where all your equipment must be kept *small*, painting "out of your pocket" might be the answer.

◄ Here you can see a slightly larger paint box, allowing for larger brushes and paper, and the more versatile moist tube colors—but you'll have to find a place to sit and something to prop your watercolor paper against!

- Greens: Mixed from yellows and blues, also Winsor or Thalo (cool).
- Blues: Ultramarine (warm), Cobalt (close to a true blue), Winsor or Thalo, Manganese or Cerulean (all cool).
- Violets: Mixed from reds and blues.

Most of my painting is done with only five or six of the above hues, occasionally more.

BRUSHES

I don't use a lot of brushes when I paint in watercolor, preferring to do most of the work with only two or three. I'll have a 1½-inch, 1-inch and ⅝-inch oxhair or synthetic hair flat brush, plus a couple of sable hair round watercolor brushes, maybe a no. 10 or a no. 8, plus a no. 6. These are more expensive than oxhair or synthetic, but perform beautifully if properly cleaned and cared for. I might also use a no. 6 rigger or script brush for linear strokes. Sometimes I'll use a ½-inch oil painting bristle brush

(called a "bright") for scrubbing out or lightening previously painted areas.

PAPER

I've found it best to use the handmade or mould-made papers, rather than the machine-made ones. One of my favorites is Arches, a French mould-made paper that comes in different surface textures and weights. I also like Lanaquarelle, Fabriano, Winsor & Newton, etc. I often use a 140-lb. cold-press (medium texture) paper, but I also enjoy painting on the other common surface textures of hot-press (smoother texture) and rough.

Most often, with 140-lb. paper, I'll stretch the sheet prior to painting on it. I do this by soaking the paper in clean water long enough that it expands slightly. While it's still damp, I staple or gum-tape the sheet around the edges to my watercolor board. When it's dry it becomes taut and easier to paint on, because it resists buckling and wrinkling.

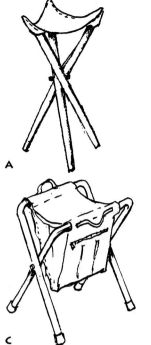

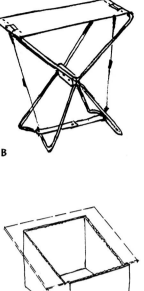

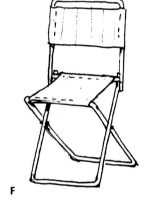

Please be seated—or would you prefer to stand? I do both, depending on the situation. Here are a few suggestions—all are lightweight and portable:

A Three-legged stool that folds and has a "saddle" seat.

B Little "web" seat that folds to a very small size.

C Reliable camp stool—this one has a canvas pouch under its seat.

D A sturdy cardboard carton, the top cut at an angle, with a notch, holds watercolor board and carries gear too! You must sit on the ground, or put the box on a table.

E A folding, adjustable wooden easel. For years I've had one of these; there's an aluminum version, too.

F Lightweight, folding camp chair.

G Two folding chairs and your painting gear: an easy way to get started.

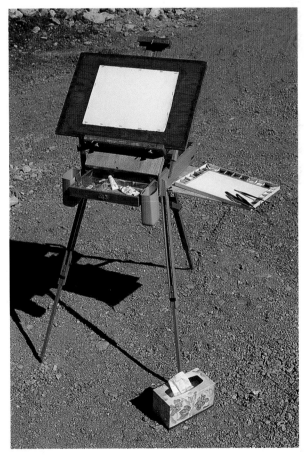

▲ "French" easels are made for oil painters who hold their palette. This one was modified with cleats underneath, so a plywood tray could be slid in to hold the watercolor palette level.

Other Items

I like to use two water containers when painting—one for clean, the other for dirty water. Absorbent paint rags or facial tissues are most useful. A common, cellulose kitchen sponge and a small natural "cosmetic" sponge are useful, too. I use a pocket or mat knife for scraping and squeegeeing. I like to use a smooth-surface paper when making my drawings and composition plans and sketches, and usually use softer lead drawing pencils. I like Pink Pearl erasers as well as kneaded erasers—both remove graphite from the watercolor paper after the painting is finished.

How to Carry It All

How you transport your painting gear and materials to the site where you paint depends a lot on how you work, what size paintings you make, how far you must go, whether you walk or drive, etc. If you prefer to paint small paintings, then you might be able to get everything you need into a little back-pack, an attaché case, a camera equipment bag, or even a large purse. If you work larger, your carrying arrangement will have to be larger, too.

On this and the following pages are shown several solutions that I've used or seen used. No doubt there are other ways, as well. A thought: Arrange all your painting things in a pile or group. This will give you an idea of what size case or bag you'll need. A visit to a well-stocked luggage shop might surprise you, for the choices and sizes of bags and cases seem endless and you may find exactly what will fit your requirements.

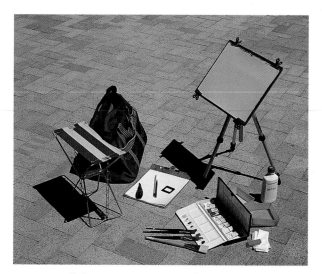

▲ Here is all the painting gear I took on a trip to Europe, where I didn't have the use of a vehicle, and travelled lightly. I painted quarter-sheet watercolors and was able to fit all you see here easily into the nylon bag that measures 13″ × 18″ × 7″. I could carry it all with one hand!

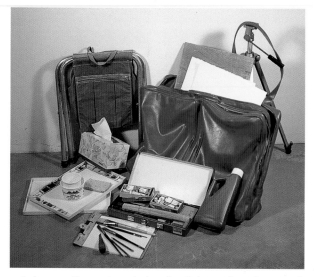

▲ I drew a dimensioned sketch of this red art bag, took it to an awning shop and had them make it for me. With a double-zippered top opening, zippered side pockets, a handle and a shoulder strap, it holds everything you see pictured here—and more. It's about 21 inches high, 28 inches wide and 4 inches deep, and can travel with the rest of the luggage on an airplane. It was made about twenty years ago, and is still going strong!

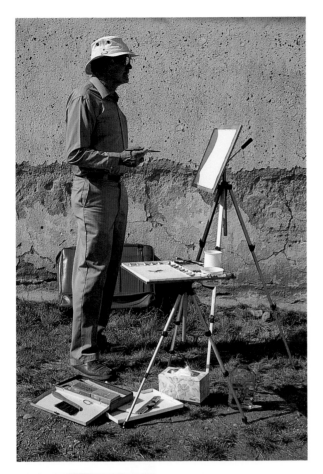

◄ The larger photographer's tripod holds my watercolor board (screwed on from the back) while the small tripod supports an aluminum pan, which makes a nice level spot for my palette, water and brushes. Everything you see here fits in the red bag in back of me. (Note: I wouldn't really paint with the sunshine full on my paper! In this case, and in some other instances in this book, it's just for the clarity of the photograph.)

▼ I know artists who've painted from the front seat of a compact car when the weather turned uncomfortable. It was *tight*, but they did it! The photo shows you how downright "comfy" a plein-air painter can be, painting from the seat of a large van. I've also heard of artists who converted the whole back end of their RVs into painting studios! So it seems painting from life can run the gamut, from a lap-held, pocket-sized paintbox to a spacious studio on wheels!

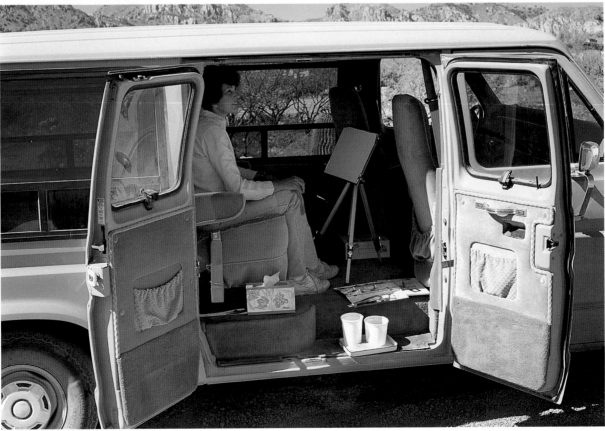

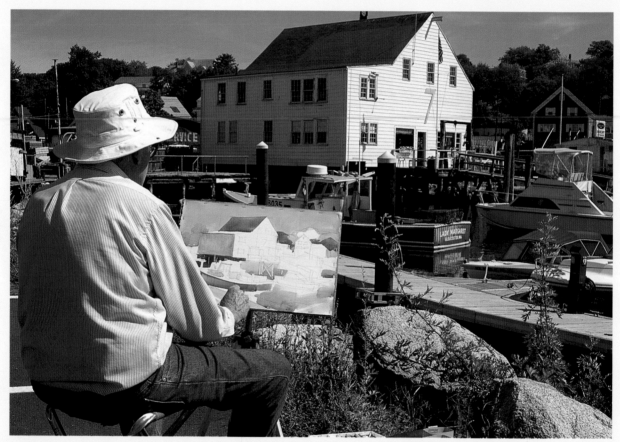

▲ Having a rather clear idea of what I wanted to paint, I first made careful drawings of elements in the scene to make sure I really understood my subject. Some of those drawings are reproduced here. Then I made several small compositional studies, or "thumbnails," to explore design possibilities for the painting. They are shown on page eighteen. After all this, I began applying broad watercolor washes to my penciled design, as shown in the photo above.

PAINTING A CORNER OF GLOUCESTER HARBOR

I can remember, as a child, seeing pictures and paintings that depicted the old fishing town of Gloucester, Massachusetts, and usually featuring the fishing boats, with their tall sails, the harbor with its various moods and the drama and clutter of the fishermen and sailors at their work. I loved the whole subject! Some of that activity and that feeling were still in evidence when I first went there to paint in the 1970s.

Recently, I returned to Gloucester to try my hand at painting the scene again. Many changes had occurred to the harbor area in the twenty years that had elapsed. Everything seemed neater and more organized than I'd remembered. No sail-powered fishing boats were to be seen. Mostly orderly wharfs, warehouses and marinas, with locked gates and high fences—certain to keep out on-location painters! However, the harbor is convoluted, with many little ins and outs, and in one of these I found a good harbor subject and a place to set up my easel and get to work painting the scene.

It was a day in late September with the leaves just giving a hint of the fall weather that was imminent. The cool air of early morning was soon warmed by a cheerful sun climbing toward the sky's zenith—a great day for painting right from the scene in front of me! And, as you can see in the photo, it was a scene with a wealth of subject matter from which to paint.

MY PAINTING GOAL

My goal was to paint a watercolor that captured the atmosphere of that little corner of the harbor as well as the ambience of the day. But with such an abundance of material, I felt compelled to edit some of it, rearrange parts and simplify detail, so the composition focused on what I wanted the painting to say.

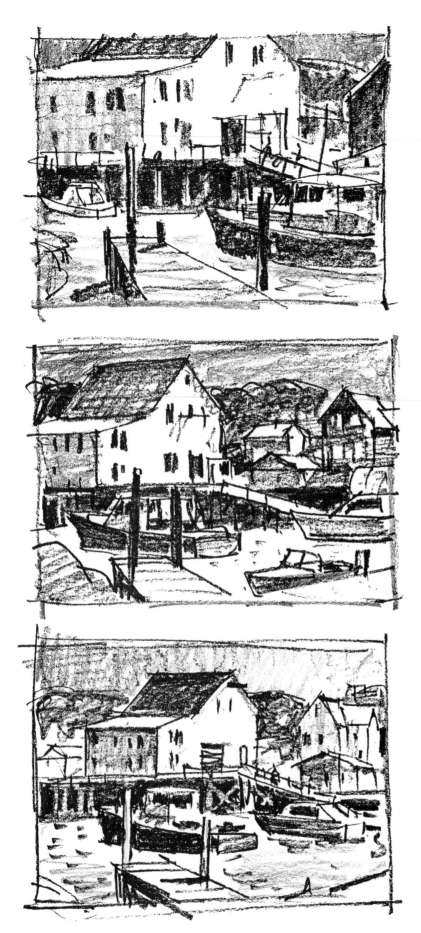

◄▼ More often than not, subjects that fire your painting impulses are cluttered, confusing, even chaotic as viewed. Almost always, some editing and rearranging of the scene's elements is necessary before a good, solid compositional design can be reached. The scene at Gloucester, though good, needed a bit of simplifying and editing, too. The little "thumbnail" studies (about 3″ × 4″) were made to explore the visual possibilities of slightly different arrangements. Although any one of them could be developed into a satisfactory painting, I decided to use the one at the bottom of this page.

► On the facing page is a photograph of the scene, taken from where I was painting. Below it is the pencilled-in design with the first watercolor washes applied. I've pointed out some of the compositional problems with the scene and the steps I took to correct them.

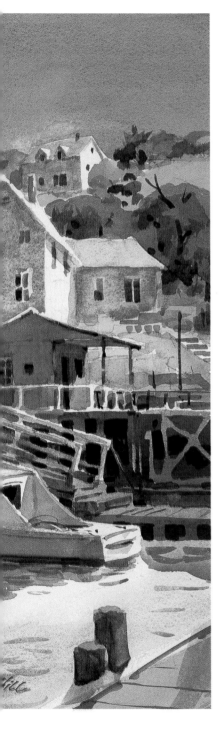

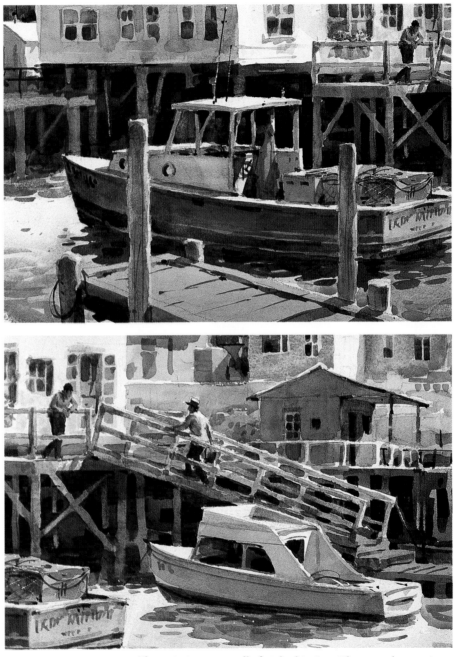

▲ **DETAILS OF STEP FOUR** The painting was really finished in Step Three on the previous page, as far as design and feeling go. All that's been added here are a few details such as ropes, antenna, tree trunks and branches, etc. The two enlargements of "pieces" of the painting, above, show some of these final touches in more detail.

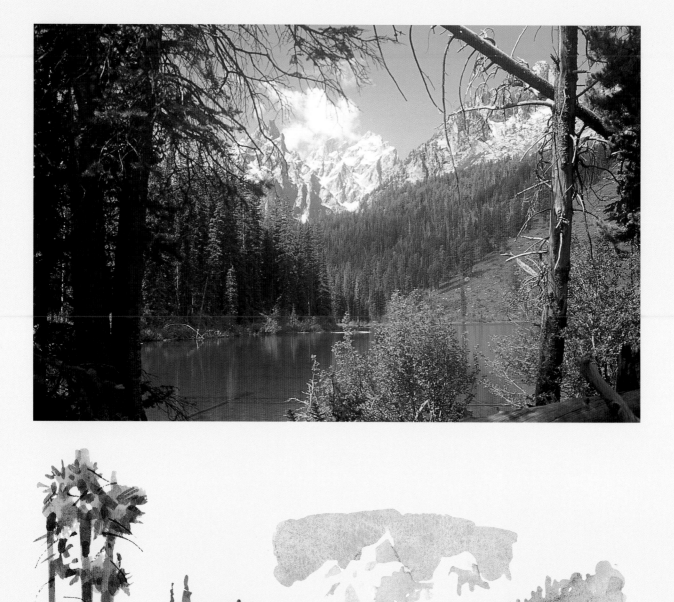

▲ When trying to organize and compose a busy and complex subject like this, I find it helpful to visualize the subject as a group of simplified shapes: the sky and peaks as one shape; the distant forested hills as other shapes; the lake as a shape; the foreground as another. I've illustrated this approach here, leaving out detail. It's almost as though I were cutting these shapes from colored paper.

PAINTING THE GRAND TETONS

The Grand Teton mountains in western Wyoming rise, like some enormous, ragged stone wall, thousands of feet above the valley floor. Almost overwhelming in their grandeur, they are indeed the "picture-perfect" subject—a subject many artists have reveled in trying to capture. These formidable peaks, with conifer forests, meadows, streams and a string of jewel-like lakes at their base, offer timeless and inspiring picture possibilities!

My first attempts at painting this subject matter were done as demonstrations for an on-location watercolor class. As I struggled to successfully paint the complicated subject matter, I realized how much I didn't know about the subject—*and* how much I was learning with every attempt. The old wisdom about having to really know and understand one's subject to be able to authoritatively interpret it in paint, came back to me with a rush!

After the class, I returned another time to paint what you'll see here. It's probably more knowledgeably painted than my first attempts, but I know there's still a wealth of things to be learned about painting these incredible mountains!

MY PAINTING GOAL

I hoped to interpret in watercolor the feeling of pristine and crystal-clear cleanliness that the setting offers—a setting that is a real challenge to paint successfully, while avoiding a "pretty postcard" result.

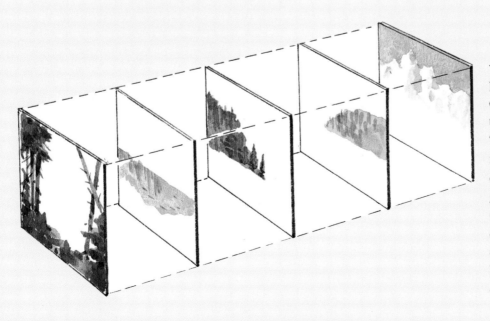

◀Landscape subjects—especially those depicting distance—can often be thought of as having "planes" in their makeup: a foreground plane; a middleground plane; a background, or distant, plane. Other intermediate planes can be introduced, as in the diagram at left, if it will help in organizing and composing the picture.

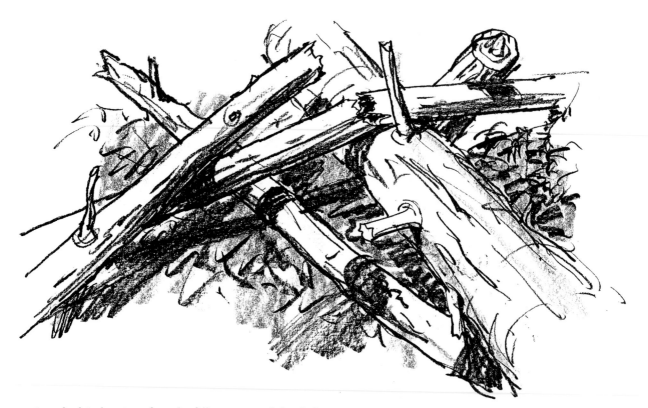

▲ I made this drawing of nearby fallen trees, and decided to incorporate them into the composition. The drawing helped a lot in my understanding of just how the trees lay and their size, color and texture.

▼► Two "rough" composition possibilities—drawn about the size of small postcards. Either solution could be made into a successful painting, but I felt the vertical composition might help contribute to a feeling of height for the trees and the mountain peaks.

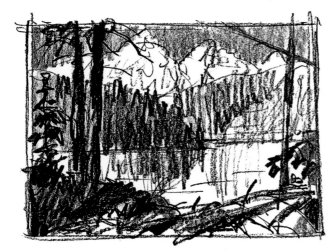

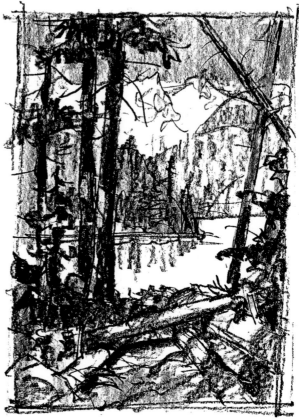

STEP ONE Painting the Grand Tetons

▼ Following the vertical "rough" as my design, I pencilled in the main elements of my picture. Then I began applying light-valued hues of watercolor wash, keeping in mind the shapes we talked about on the preceding pages. After dampening the lake area, I painted it wet-in-wet, adding the reflected trees when the dampness was just right. Using a damp brush and clean water, I lifted the lake color from the tree trunks.

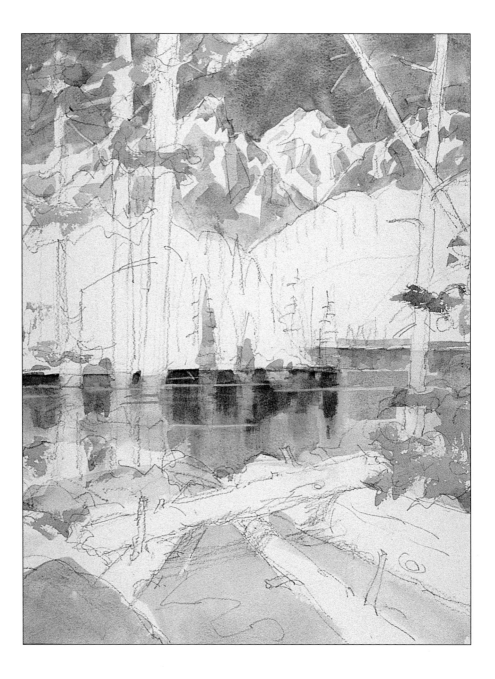

STEP TWO Painting the Grand Tetons

▼ The two forested hills across the lake were painted in light values of the greens I saw in them. I also painted the lightest values—both warms and cools—on the trees and logs, and added more foliage shapes.

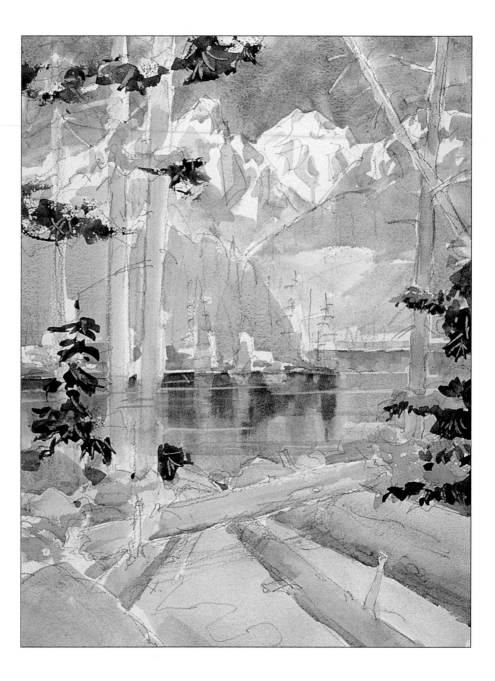

STEP THREE Painting the Grand Tetons

▼ I painted the tree shapes on the forested hills, mostly in middle to slightly darker values, then the shadows on the trees, logs, rocks, etc. All the while, I added the various greens of the foliage. The cast shadows, carefully observed and planned, were added, and helped greatly in giving dimension to all the forms.

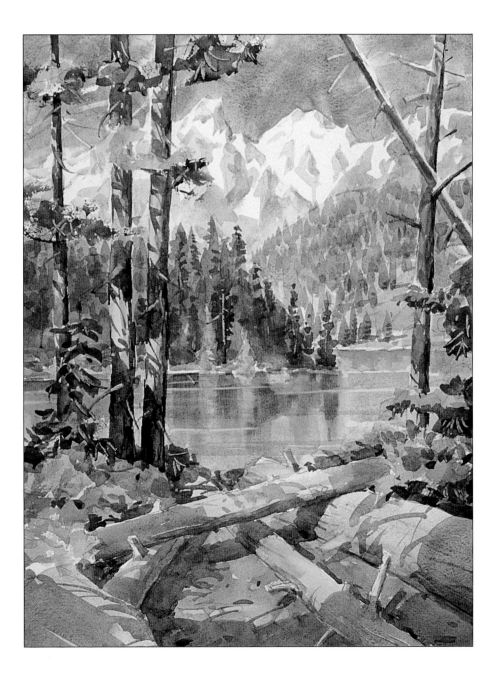

STEP FOUR Painting the Grand Tetons

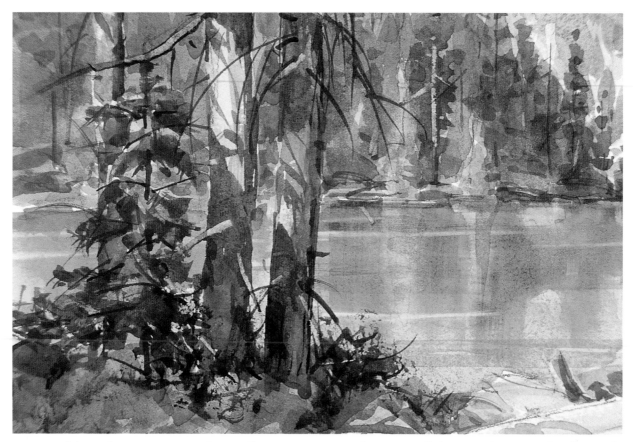

▲▼ More foliage shapes were painted, as well as twigs, branches, etc. The two enlarged details on this page give you a good look at the warms and cools within the shadows, as well as some cool glazes I laid over various foreground areas to pull them together. Note also the simple shapes of the reflections on the still water.

▶ VIEW ACROSS STRING LAKE 16½″ × 12¼″

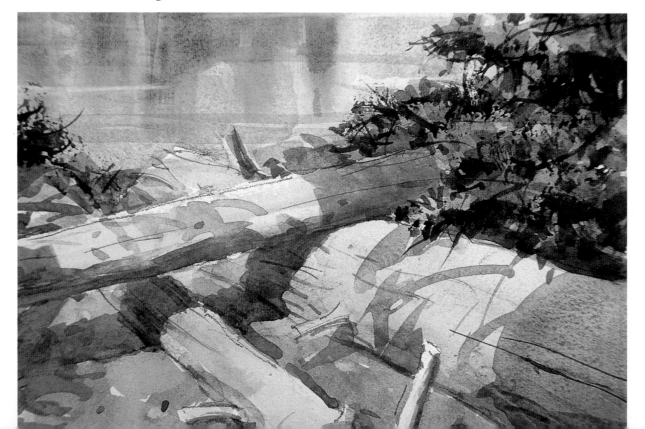

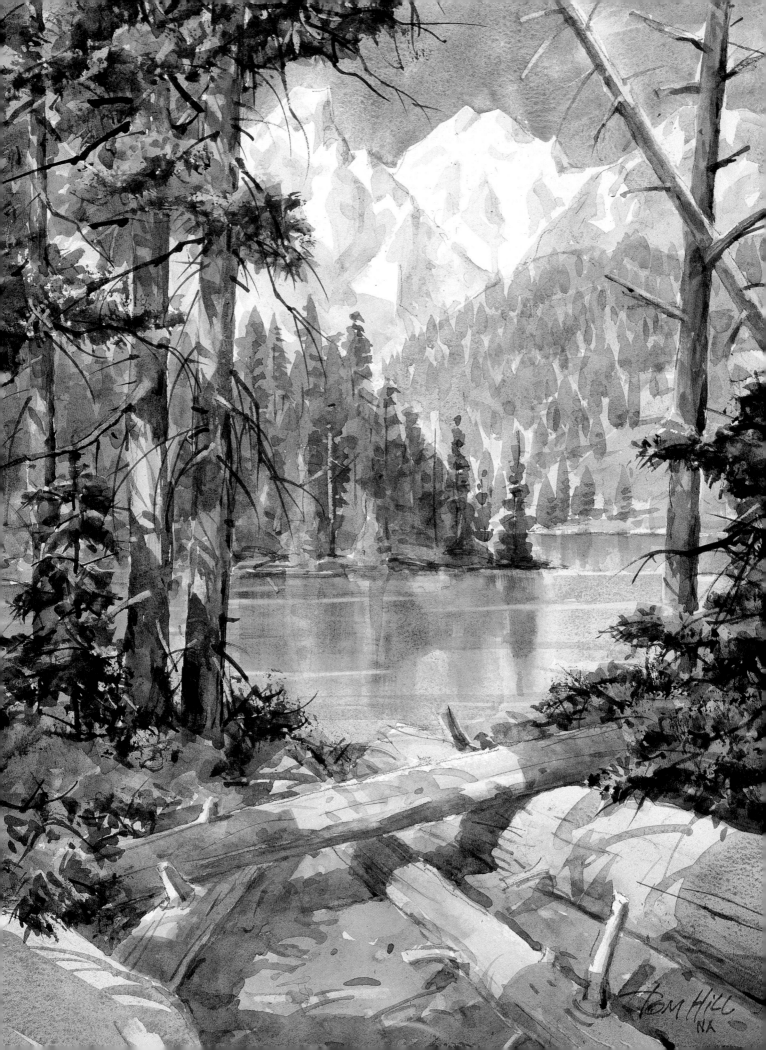

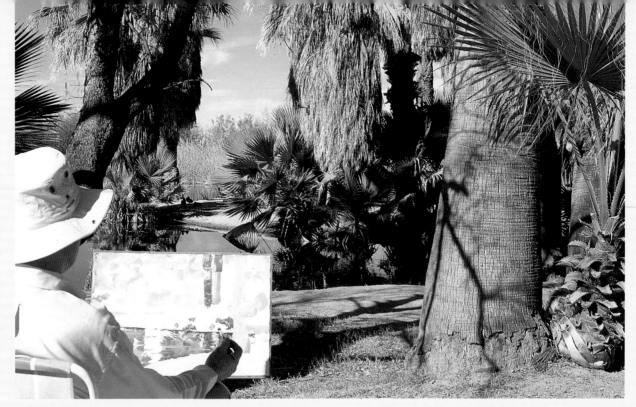

▲ This photo gives you an idea of the advantages of on-location painting: All the information you need is right in front of you, all you need do is *look*! In many cases, you can walk up to or around your subject—look closely, touch, even smell! Memory, sketches and photos, so relied on in studio painting, can't equal the knowledge and feeling obtained by direct observation. And it's knowledge and feeling, coupled with skill, that make *good* painting possible!

▼► Palm trees are amazingly constructed. I made several drawings of their structure so that I felt more comfortable in trying to interpret them in watercolor.

Chapter Four

PAINTING AN OASIS IN THE DESERT

Southern Arizona, where I live, is part of a desert that covers a large part of Arizona and extends far south into Mexico. It's not as dry as many deserts, but water is still precious.

So, a natural and permanent body of water is rare and possesses a jewel-like quality. Not far from my house is such a phenomenon—an oasis in the desert. Fed by underground streams from nearby mountains, the water wells up to the surface, forming a small lake.

Over the years, grass, reeds, cottonwood and sycamore trees have somehow arrived at this oasis, taken root and prospered. In addition, desert palms have grown in profusion, their fan-like fronds waving in the passing breeze against a bright blue sky, while the many shapes created are reflected in the calm waters below. Surrounding the oasis is the desert, surviving as it always has, and lit by brilliant sunshine. The setting is at once arresting, as well as visually and emotionally exciting to the eye, and begs for an interpretation in watercolor!

MY PAINTING GOAL

I wanted to capture in paint the wonderful feeling of contrast between the warm, dry desert and the cooler lushness of the foliage, growing beside and sustained by the oasis.

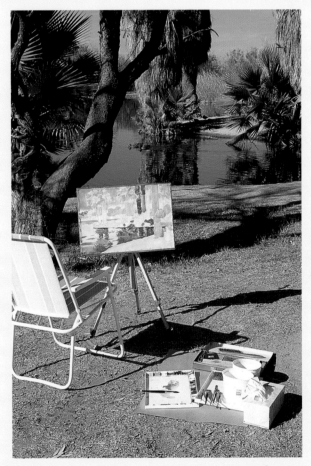

▲ With my vehicle close, I can carry more gear to the site. So, though outside, I still have a few of the comforts of my studio: a proper-height chair, a tiltable easel, and my painting gear on level ground by my side.

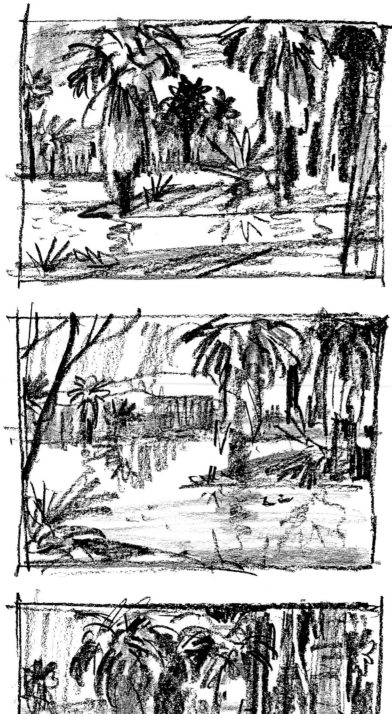

◄ To arrive at a better design for my painting, I first made little 3″ × 4″ pencil roughs or "thumbnail" sketches, trying out different arrangements of the shapes I saw before me. I settled for the one at the bottom, and transferred the design to my watercolor paper.

► At the top of the facing page is a photo of my subject. Below it is my pencil drawing on watercolor paper, ready for paint. Though at first glance a scene like this seems almost perfect, it still needs some editing and rearranging. I have pointed out some possible faults in the actual scene and what I thought would correct or improve them in the drawing.

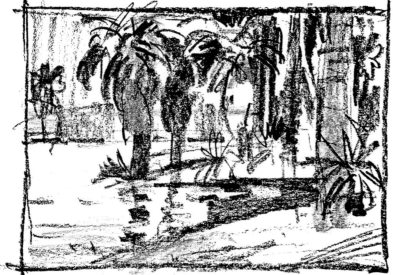

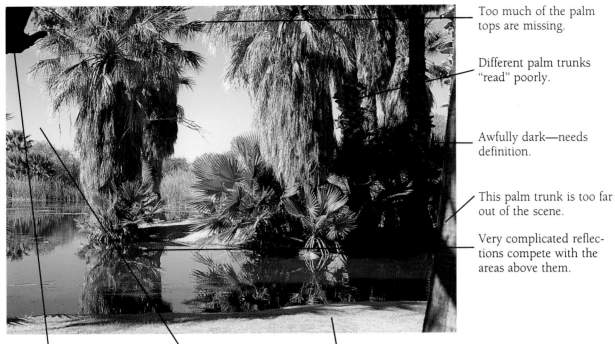

Too much of the palm tops are missing.

Different palm trunks "read" poorly.

Awfully dark—needs definition.

This palm trunk is too far out of the scene.

Very complicated reflections compete with the areas above them.

Black mesquite tree limb adds nothing useful.

Some sort of distant background would help.

Boring foreground, too parallel to bottom of image.

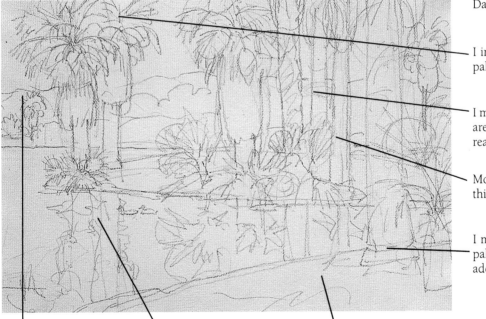

Dark mesquite limb is out.

I included more of the palm tops.

I made palm trunks in this area more defined and readable.

More light and color into this area.

I moved the foreground palm into the scene and added a baby palm.

There are mountains to the right of the scene. I decided to move them into my painting's background.

Reflections are to be made simpler, but still be reflections.

I sloped foreground and planned to add cast tree shadows across it.

STEP ONE Painting an Oasis in the Desert

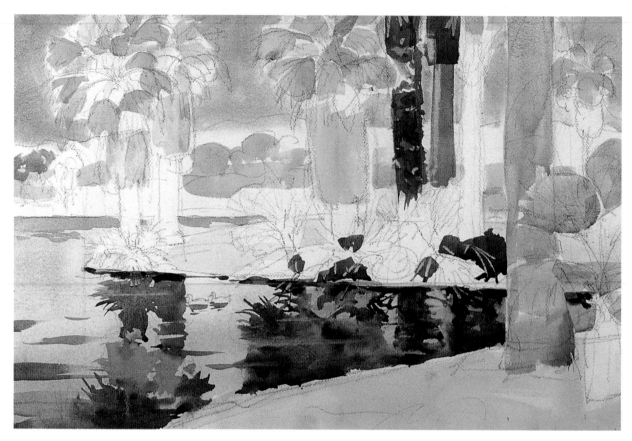

▲ I wet the lake area with clean water, then painted sky reflections with Cobalt and Manganese Blue, using a 1½-inch flat brush. While the area was still damp, I dropped in reflection shapes with 1-inch flat and no. 10 round brushes, using mixes of Thalo Green, Burnt Sienna, New Gamboge and Ultramarine Blue. I painted the sky area with the same blues as the water, and blocked in the shapes of palm fronds and trunks.

▶ **DETAIL** Here you can see how the reflections were "dropped" into the damp wash—simple shapes, some still wet, others already drying to "crisp" edges—echoing what was to be painted above them.

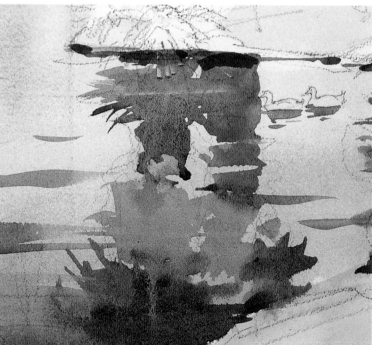

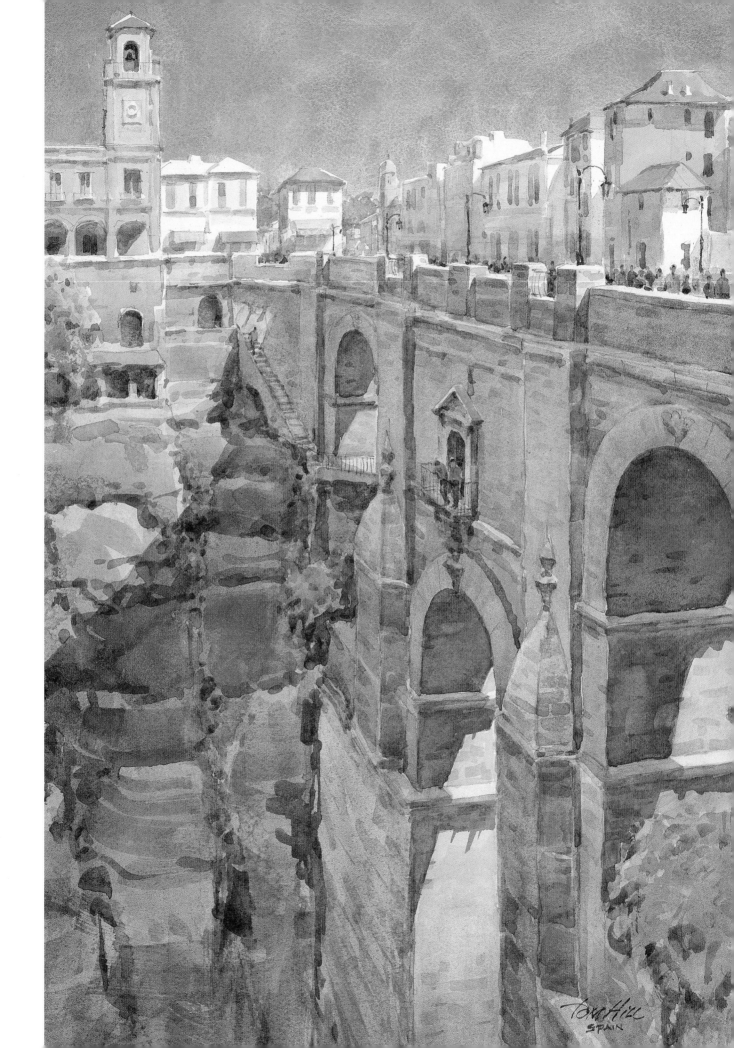

Tom Hill
SPAIN

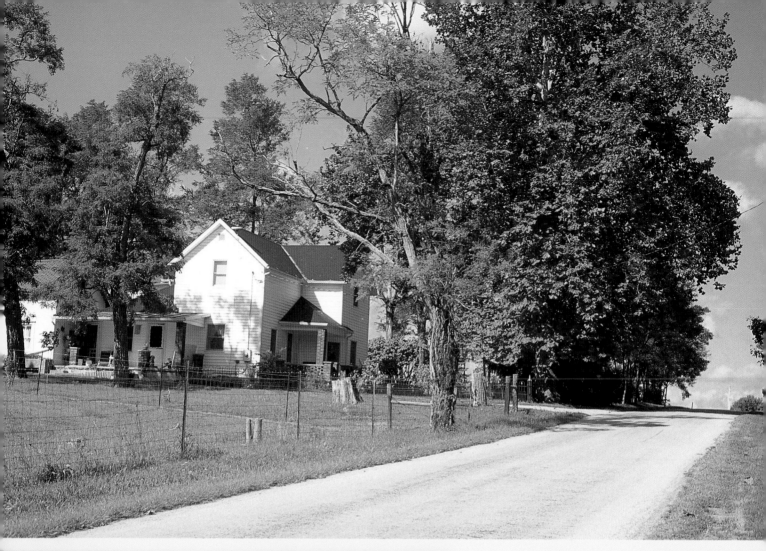

▲ There's a straightforward look about this neat, white farmhouse—functional, not too fancy, with rather simple windows, doors and roof lines. Still, it portrays a comfortable and homey feeling and almost seems to represent an America of simpler and more honest times that existed not too long ago.

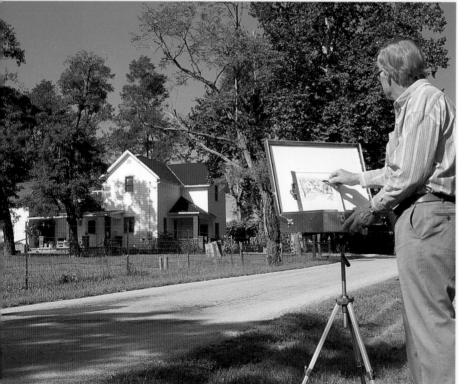

◄ I positioned myself across the road from the house and got started with my roughs (see page 64). For an easel, I was using an aluminum case that I attached to a tripod; the idea was to carry everything in one "suitcase," so to speak. It worked OK, though I found I had to steady it a bit when painting small details.

Chapter Seven

PAINTING A MIDWEST FARMHOUSE

If you live in a desert climate, as I do, it is always a pleasure to drive through the farmlands of the middle west and enjoy the green fields, shady trees, the farm buildings and all the paraphernalia that goes with farming. There's one good painting subject after another!

The farmhouse shown at left is typical of many I saw driving through Ohio on a recent trip. It looked like a good subject for a painting—especially as it was situated on the crest of a small hill, was old enough to have a nostalgic kind of character and, in the morning sunshine, presented some interesting light and shadow patterns to work with in the painting process. The huge trees offered exciting shapes that could be used to set off the shapes of the building, but would need some editing so as not to appear to dwarf the house. I felt the straight road could be made more interesting too, and capable of adding some dynamics to the composition.

After setting up my painting gear and starting to study the painting possibilities by making compositional-value studies, it seemed to me that there was a certain sameness in the greens that were everywhere in the scene, and these greens could be modified and changed in favor of the painting.

No one was in sight when I began, but after a while, a pickup truck approached and passed by me. I decided to put that truck in the picture, under the trees, and to have a figure alongside it as well. This would give life and scale to the scene.

MY PAINTING GOAL

I wanted to take this scene of a sunny, late summer morning and a neat old white farmhouse on the brow of a gentle hill and create from it a painting that would describe the feeling of the scene even more succinctly than the scene itself.

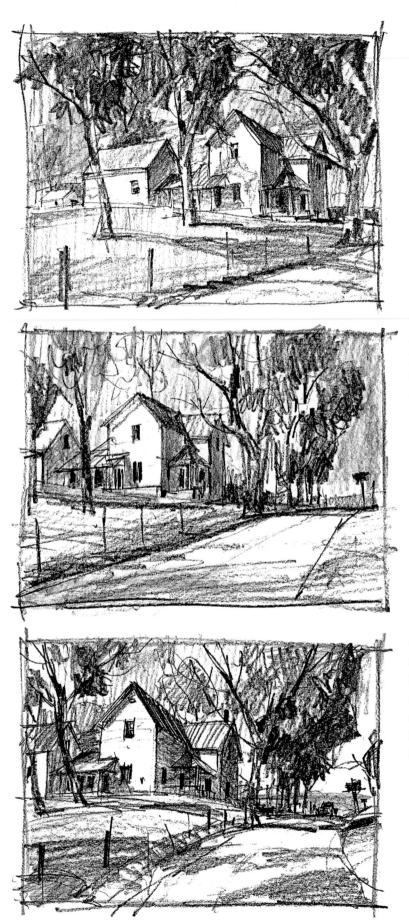

◄First, I tried featuring *all* of the farmhouse, framed by the trees with the road a minor element. After studying it, I felt it was too centered.

◄Here, I moved the building off-center, losing some of it to the left. This seemed better, but the straight road made everything seem a bit static and not too exciting.

◄This is the rough I liked best. I think the curved road adds a bit of movement, and helps lead the viewer's eye into the interesting shapes, light and shadow patterns and details of the house and its surroundings. From this rough I pencilled in the drawing on my watercolor paper.

STEP ONE Painting a Midwest Farmhouse

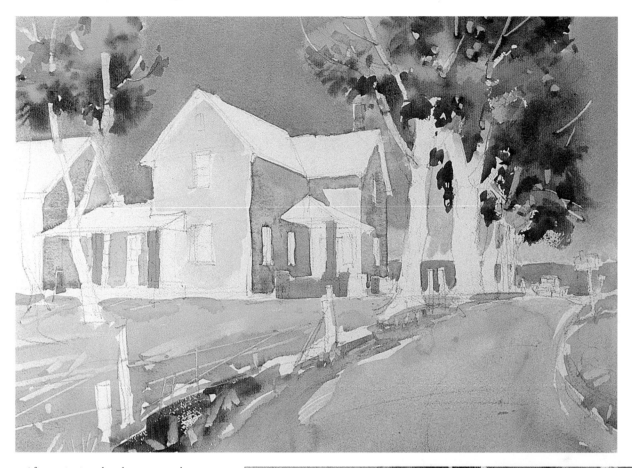

▲ After painting the sky area on dry paper, I charged in some of the tree foliage while the paper was still damp. I made the grass area yellower, to relieve some of the greenness.

▶ **DETAIL** Here you can see how both warm and cool hues were mingled in the same flat washes on the shadowed walls of the house.

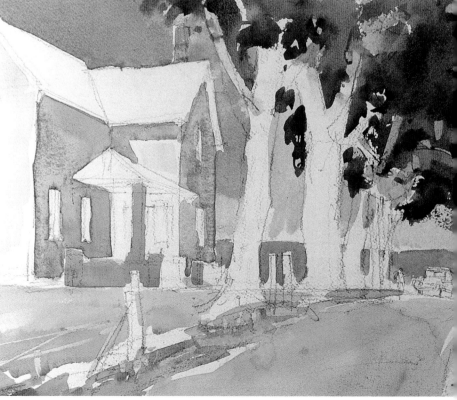

STEP TWO Painting a Midwest Farmhouse

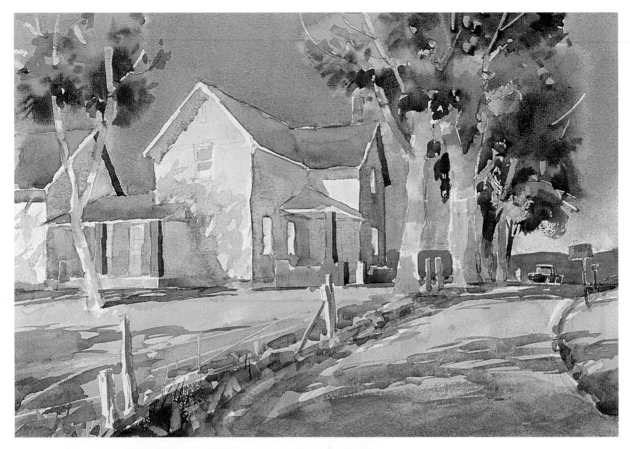

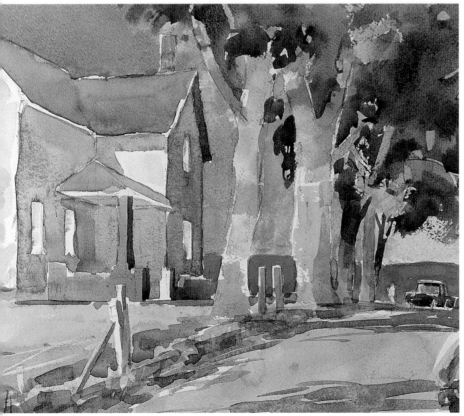

▲ Using simple combinations of reds and yellows, grayed here and there with blues, I painted the warm hues of the tree trunks, porch supports, etc. I added cool cast shadows to the sunlit side of the house, the lawn and across the road. The shadows across the road were not actually there, but were added as a design and atmosphere element to help the painting—part of the "editing" I mentioned earlier.

◀ **DETAIL** The roof color was made from Permanent Rose, grayed with a little blue and yellow. I darkened the hills with a glaze of the original wash: Cobalt Blue and a bit of Permanent Rose.

STEP THREE Painting a Midwest Farmhouse

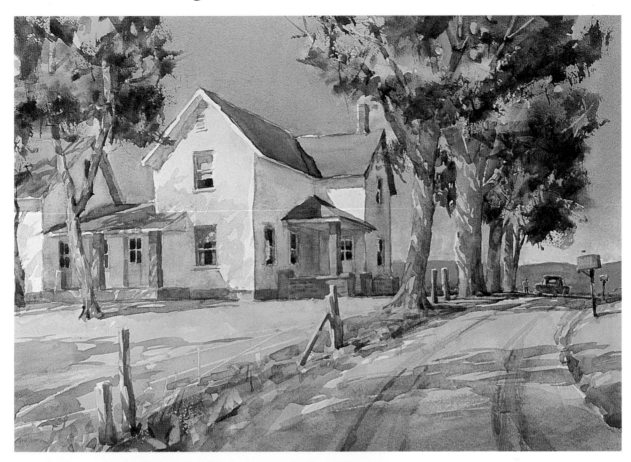

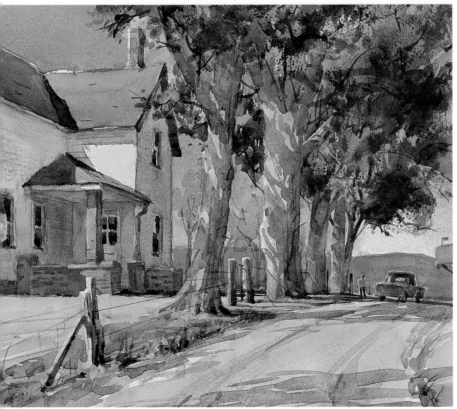

▲ The painting neared completion as I added details such as windows, doors, ruts in the road (these ruts are also an "editorial" addition), and cast shadows on the roof—which, by their shape, help explain the structure of the roof. At this point, the painting is actually finished insofar as its design, color and feeling are concerned. A very few final touches will be all it needs.

◀ **DETAIL** I added darks to the tree foliage using a very rich mix of Thalo Green, toned down and warmed with Burnt Sienna.

STEP FOUR Painting a Midwest Farmhouse

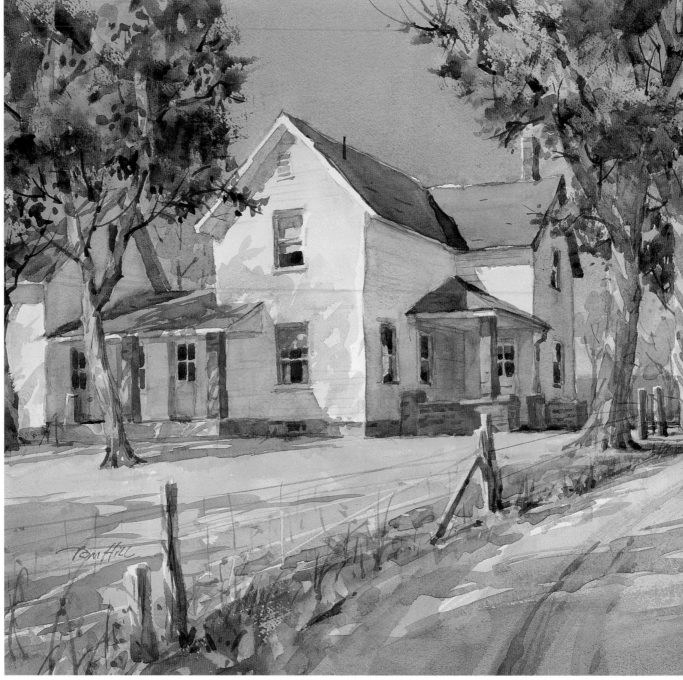

▲ I added some light-valued, smaller trees in back of the other trees and the house to help give the feeling of lots of space between the house and the distant hills. If you look at the photograph on page 62, you'll see a lot of large trees in back of the house, which I edited out in favor of more visual impact for the house itself.

My final efforts were to add small branches, fence wire and a faint indication of clapboards on the walls of the house. A little of this sort of detail goes a very long way, so I didn't do more than a hint of it! I believe most viewers enjoy having something left for them to imagine.

FARMHOUSE ON THE HILL 13″ × 18½″

▲▼ DETAILS OF STEP FOUR

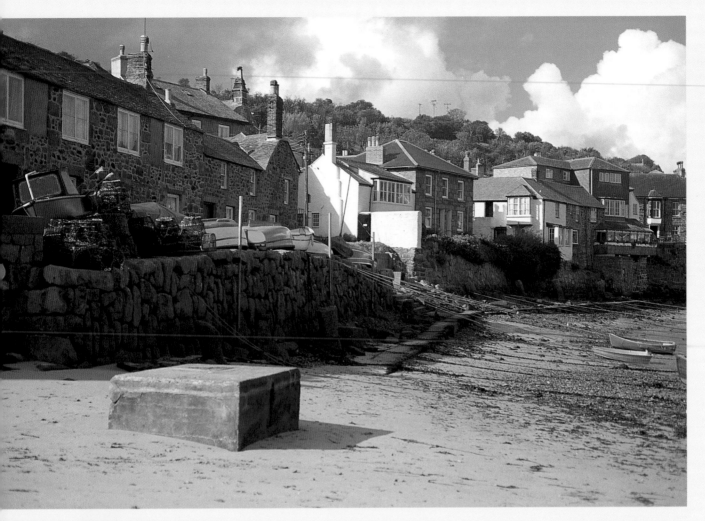

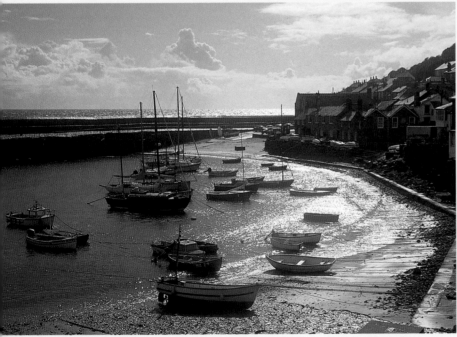

▲ This is a view of Mousehole, taken from about where I stood to paint. These venerable buildings face the tiny harbor, the seawall and the ocean.

◄ Here's another view of Mousehole, taken from the opposite side of the harbor area. You can see the beach where I painted, the large seawall and breakwater, and the English Channel beyond.

PAINTING THE VILLAGE OF MOUSEHOLE

The local folk say "Mowzole," running the sounds together. The map of Cornwall, England, reads "Mousehole," and that's appropriate, for it is, indeed, a very small town with a *tiny* harbor, protected from the sometimes raging English Channel by a *big* seawall! Driving along the coast of Cornwall presented one fine painting subject after another—and little Mousehole was no exception. I was enjoying the early October weather: sunny ten minutes, then fast-moving rain clouds for another ten (all the while a blustery wind whipping in from the sea) then back to sunny again. Exciting weather and great scenery!

I went down to the harbor's little sand beach, intent on painting as best I could despite the wind and ever-changing weather. I had to tie my tripod easel down with strong string attached to a heavy rock, just to keep it from blowing over. Occasional drops of seawater hit my back, having been blown right over the seawall and far enough to reach me.

But it was all very much worth the effort and inconvenience. It was so exhilarating, and the painting information that was directly in front of me was certainly superior to having only sketches or photos to paint from, useful though those things are. I was able to complete the painting on location, except for a few final touch-ups, which I did later that evening.

MY PAINTING GOAL

I hoped to paint a watercolor that says clearly to all who see it: "This is an old seacoast village, and it's a blustery and exhilarating day." As you watch how the painting is completed and look at the final result, I hope you'll agree I reached my goal!

▲A drawing I made of the subject prior to painting it.

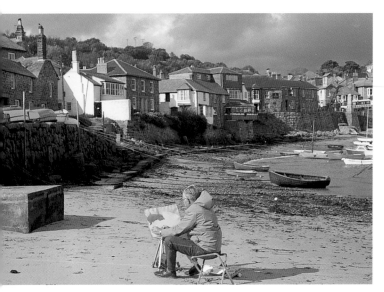

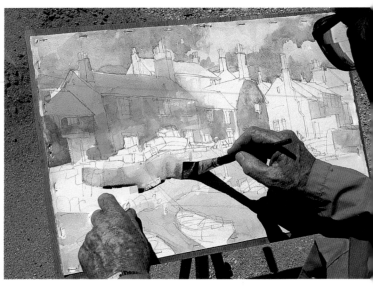

▲ Painting on the beach at Mousehole.

▲ The painting in progress, as I start a grayed blue-violet wash to act as a background value for the wall's rock shapes, which were added after this.

◀ I used a heavy rock from the beach, tying it to my tripod-easel with a strong string, so that it hung slightly above the sand. This kept the rock's full weight in force and held my watercolor board fairly steady in the wind.

▼ Here's a compositional design and value study (reproduced actual size) which I referred to as I pencilled my design onto the watercolor paper.

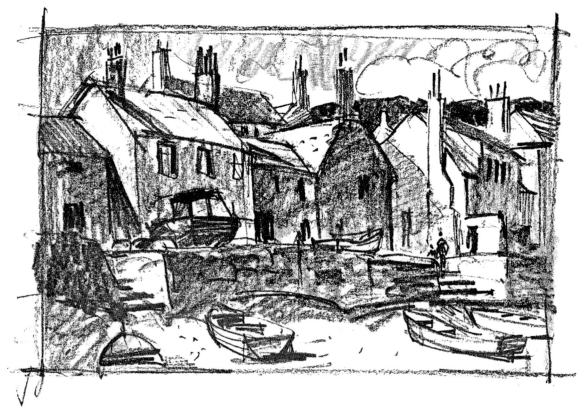

STEP ONE Painting the Village of Mousehole

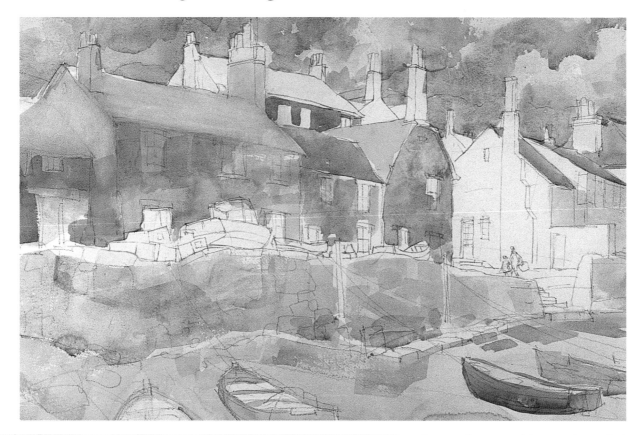

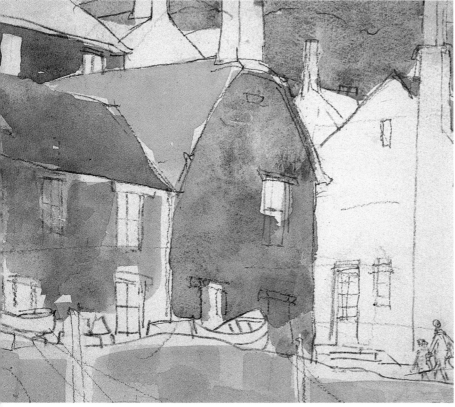

▲ Because I was working nearly vertical with the wind blowing, I painted mostly flat patterns of watercolor wash on dry paper, the only exception being a little wet-in-wet on the sky and foreground areas. I was able to "charge" some warm and cool hues into flatly painted places before they dried, as in the faces of the buildings.

◄ **DETAIL** The enlarged detail shows this warm and cool "mingling."

STEP TWO Painting the Village of Mousehole

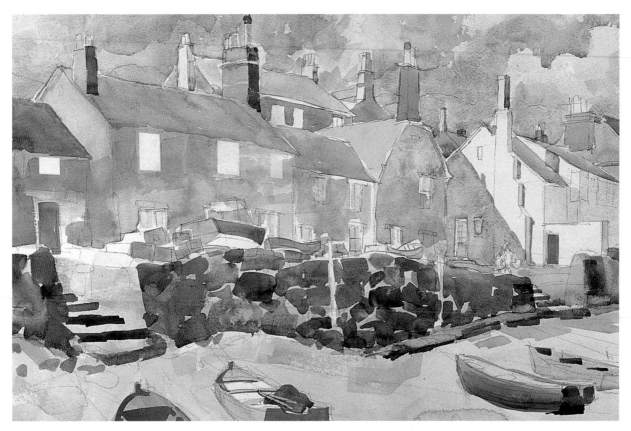

▲ Using a 1-inch flat brush, I painted the rock shapes on the wall by the sand. Then I painted the shadows on the white building and the boats that were pulled up on the sand. I also painted more roof shapes and indicated the stone steps.

▶ **DETAIL** By mixing complementary colors, I achieved nice darks—both warm or cool in color cast, for example, blue with orange (Burnt Sienna), reds with greens, yellows with violets, etc.

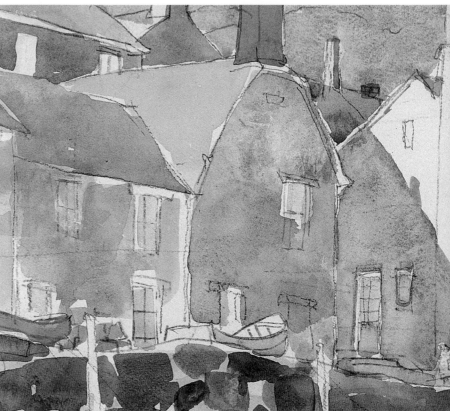

STEP THREE Painting the Village of Mousehole

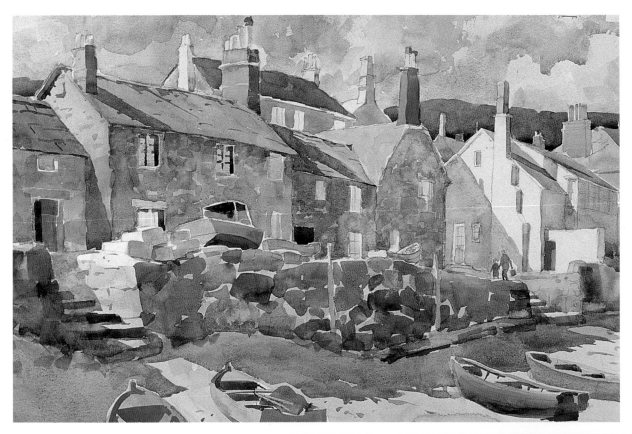

▲ I painted the dark hills in back of the rooftops, the cast shadow on the sand in the foreground, more details and shadows on the boats and buildings.

▶ **DETAIL** I added flat washes to the building walls to indicate stone patterns. I did this by glazing this wash directly over the previous wash, while leaving bits of the first wash showing through.

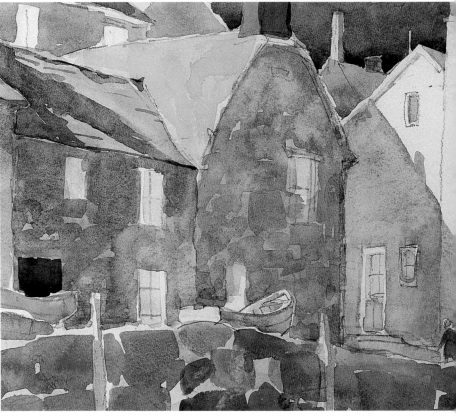

STEP FOUR Painting the Village of Mousehole

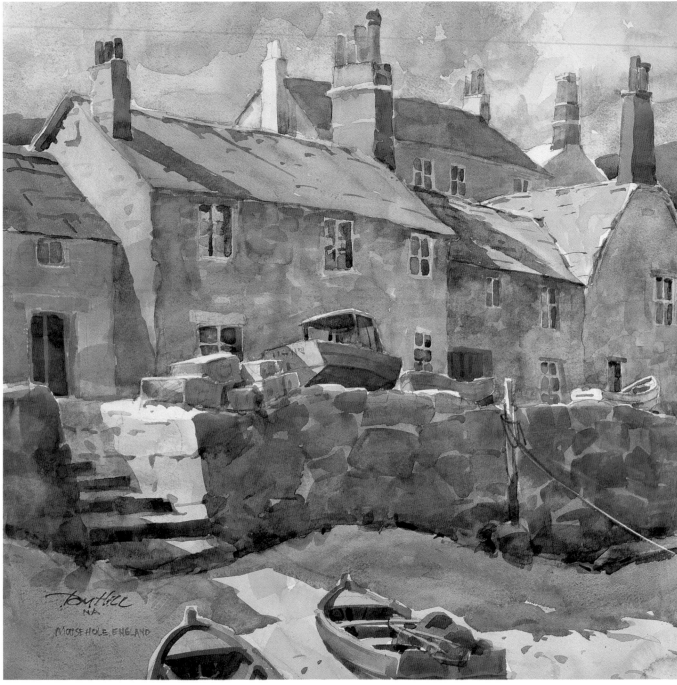

▲ BLUSTERY WEATHER, MOUSEHOLE, ENGLAND 14″×21″

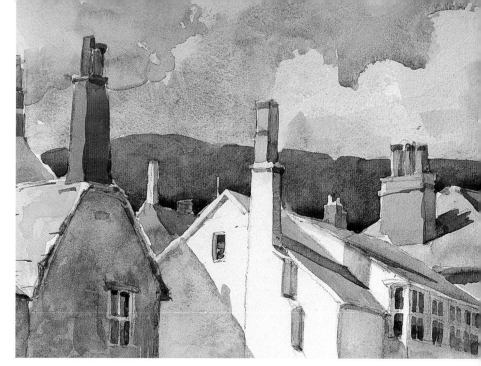

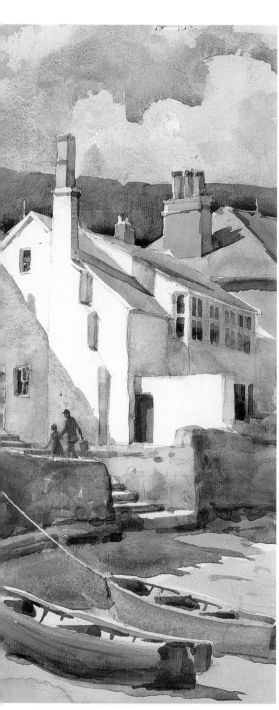

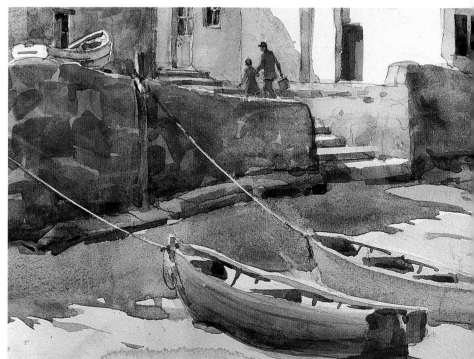

DETAILS OF STEP FOUR

I finished the painting by adding a few final touches and details: the darks and reflected lights in the windows and doors, some refinement of the two figures, the boats and the fish traps. The three enlarged details show better how some of this was accomplished.

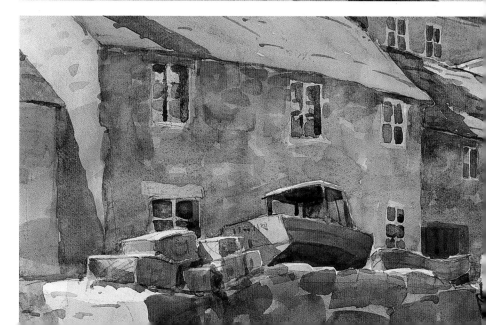

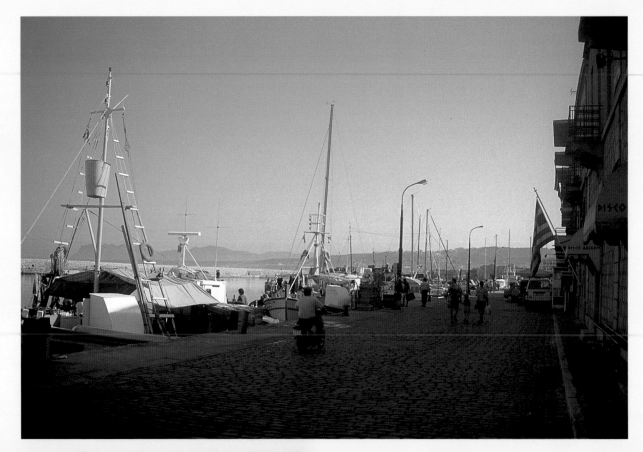

▲ I took this photo just before starting to paint. The light was poor, and some of the detail in the shadows is not very evident, but it gives an idea of the scene I was about to paint.

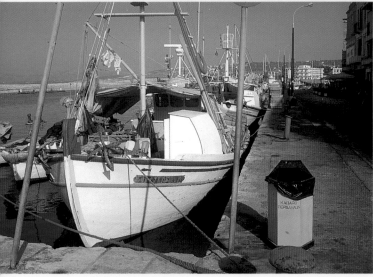

▲ ▶ These photos were taken later, when the painting was basically finished, but they help describe the subject and the feeling of the place. Needless to say, I edited and simplified a lot of the detail in favor of the impact I was reaching for.

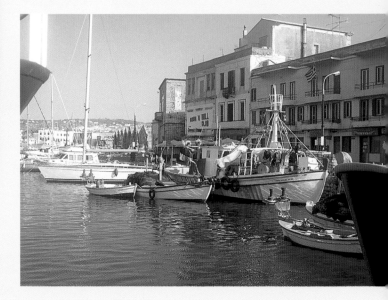

PAINTING EARLY MORNING LIGHT AT HANIA

Not long ago, we went on a painting trip to the Mediterranean island of Crete. It was late in the summer, and most visitors from northern Europe and America had left for their homelands, so there was a tranquil air about the place. We stayed a while in the old city of Hania. Now, Hania is *old*— said to be one of the oldest continuously inhabited cities in the world! Over the centuries, Minoans, Greeks, Macedonians, Romans, Venetians, etc., have called it home, each culture leaving at least a trace of having been there.

Today, however, Hania seems anything but old! With its curving harbor, busy markets, shops, warehouses, fishing fleet, summer visitors, etc., the hum of business and trade is everywhere. Still, an overall, laid-back ambience is everywhere, too. Old Venetian-style buildings ring the harbor, their reflections shimmering in the calm water; open-air cafes and bars offer relaxation with a waterfront view; fishermen and their boats are constantly coming and going. Lots of great painting material, offering the opportunity to create exciting watercolors.

Bent on painting the harbor scene, I arrived early one morning, just as the sun was coming up over the hills to the east. Rounding a corner of the quay, I was suddenly struck by a fine painting subject directly in front of me. (The photos at left give an idea of the setting.) I was standing in the shadow of the buildings on my right, while straight ahead of me the morning sunlight was streaming across the wharf, the fishermen and their boats, the distant warehouses and the hills in back of them. I knew this effect and feeling wouldn't last long, so I set up my painting gear and got started!

MY PAINTING GOAL

What I hoped to accomplish was to capture the effect of the brilliant morning sun, cutting low across the scene, lending a feeling of anticipation for the coming day. The foreground buildings and quay provided exactly the darker visual framework to help the painting work. Of course, this meant editing out elements that would detract from the feeling and concentrating on keeping—or even adding—those things that would enhance it!

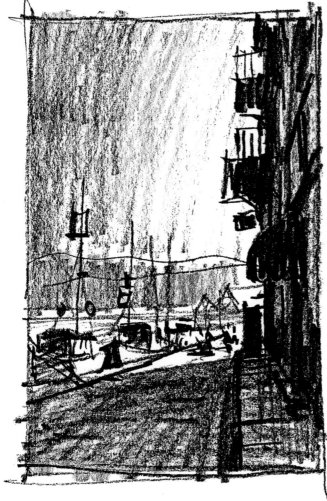

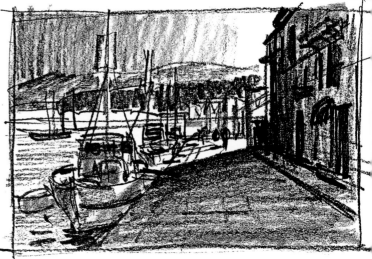

◄▲ I did three rough compositional value studies in great haste, trying to get to the painting while the light was still so good. I used the one at the top as a best bet, though any would have worked.

STEP ONE Painting Early Morning Light at Hania

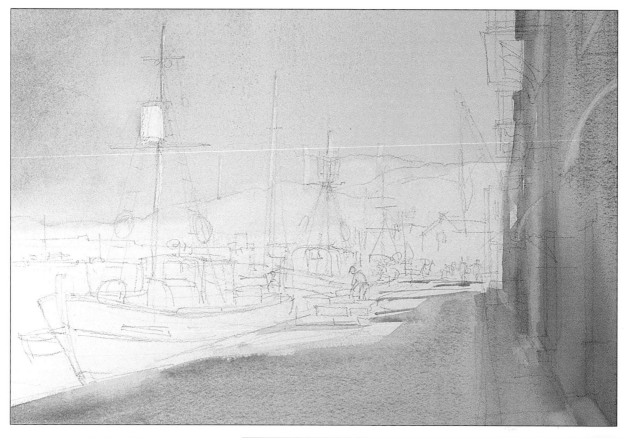

▲A graded wash, from blue-violet to light yellow, made the sky. Warms and cools were mingled, wet-in-wet, on the building, while a simple blue-toward-violet wash was put on the quay. I scraped out the ship masts while the sky wash was still damp, and, with a clean, slightly damp 1-inch flat brush, I lifted some paint out of the building wash. These lighter areas would become the tops of the awnings and steps a little later in the painting.

▶ **DETAIL** Here you can see some of the lift-off effect a little better.

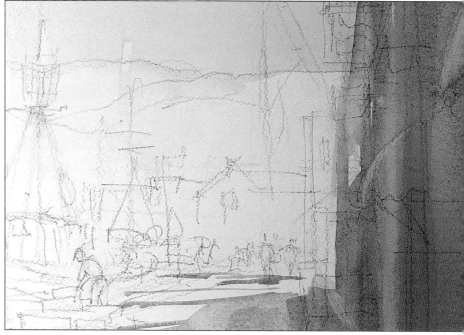

STEP TWO Painting Early Morning Light at Hania

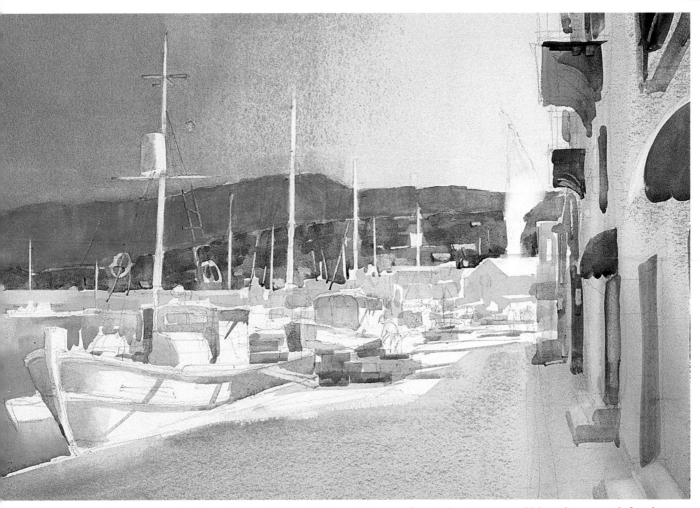

▲ I decided that I hadn't made my sky area dark enough, so I applied another wash of the same color combination—a glaze—and made it darker. After it was dry, I masked around the boat masts and crows nests with masking tape, then, using a ½-inch bristle brush, I gently softened the pigment and blotted it out with facial tissue. Next, I painted all the remaining areas, treating them as basically simple shapes, as is clearly shown in the enlarged details on the facing page.

▲
▼ DETAILS OF STEP TWO

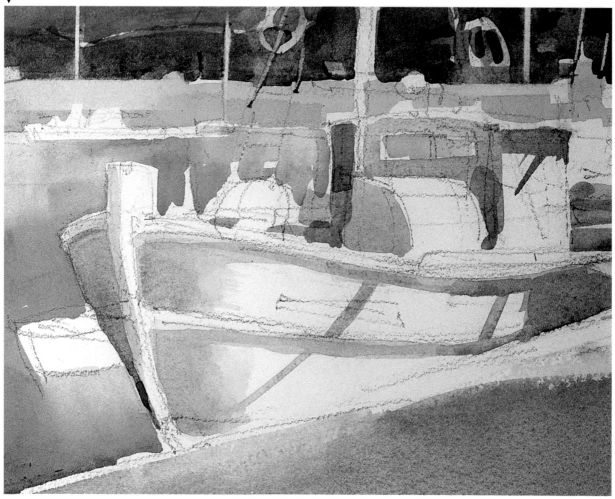

STEP THREE Painting Early Morning Light at Hania

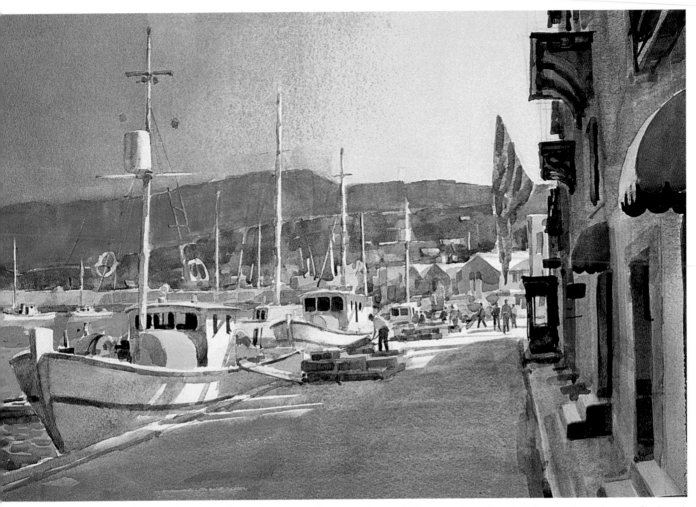

▲ I painted more shapes, including some smaller ones. I studied it and then changed the shadow on the first boat, and decided that the shadow on the waterfront quay needed to be darker. So I glazed it with a darker wash of the original mixture and left more variations of value within that glaze. I added figures (see chapter five) and other details but, as the two enlarged details (at right) reveal, I refrained from using little brushes and painting picky details!

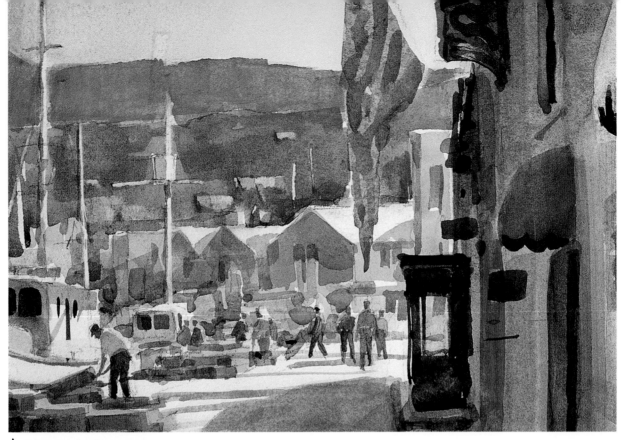

▲ DETAILS OF STEP THREE
▼

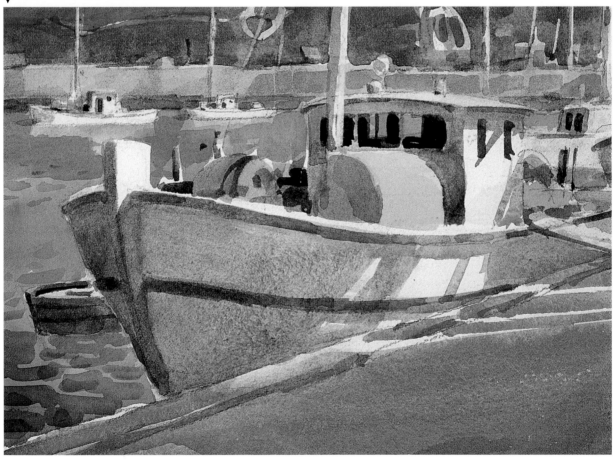

STEP FOUR Painting Early Morning Light at Hania

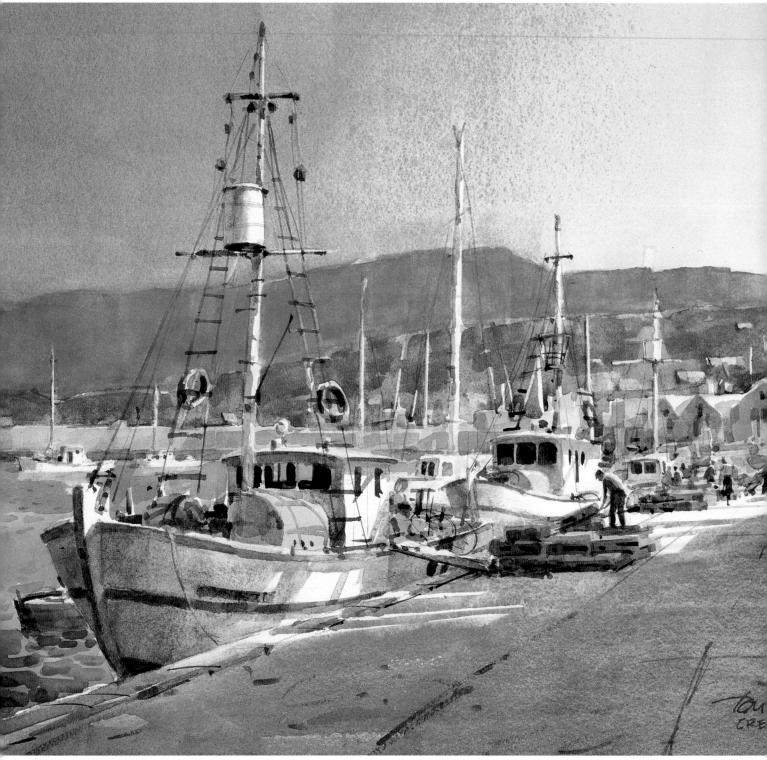

▲ Now that the painting was essentially solved, I felt that it was OK to add a few little touches—to "button it up." I painted indications of rigging and ropes, iron railings, shadows on the figures, the flagpole, etc., using a no. 6 round red sable watercolor brush and a no. 6 "rigger" brush. Even so, I think you'll agree, I kept it all quite casual with lots of impressionistic areas, so that viewers can read their own details into it!

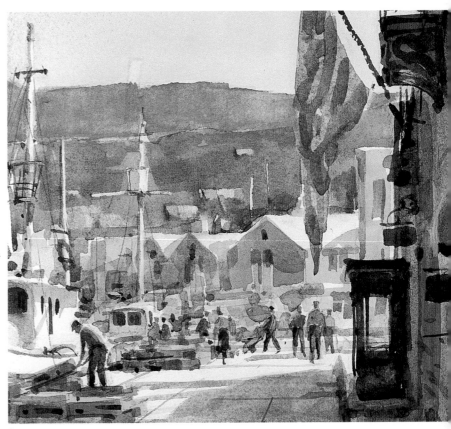

DETAILS OF STEP FOUR

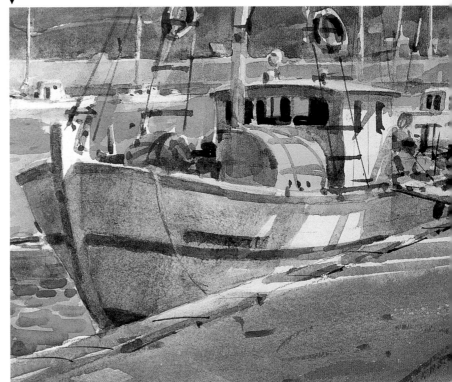

▲ MORNING, HANIA HARBOR, CRETE 13½″ × 20″

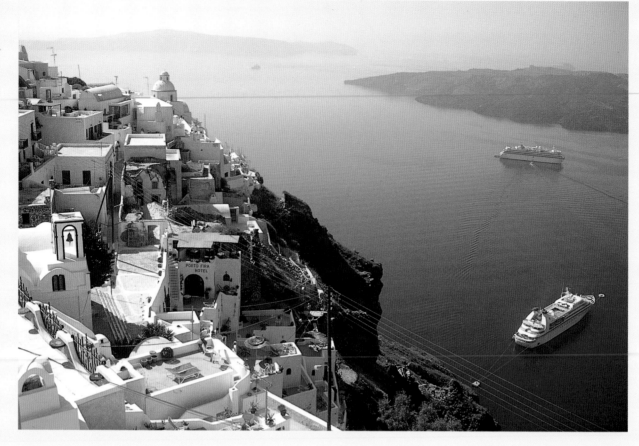

▲ This photo shows the town of Fira by morning light. Notice the amazing jumble of buildings, walls, walks, cliffs, etc. All of this will need organizing and simplification for the painting to make sense. The sea here is so deep that the cruise ships can anchor quite close to the cliffs below. Some of the rest of the island can be seen in the distance.

▶ This is an afternoon light photo of about the same area. The scale and ruggedness of the lava cliffs shows clearly against the sun's glare on the water.

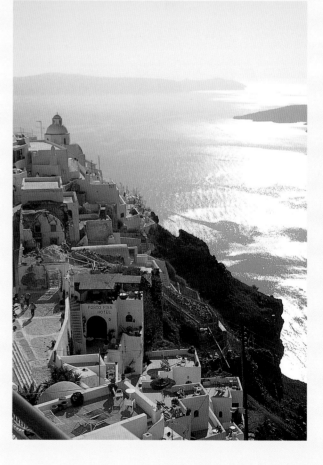

PAINTING THE GREEK ISLAND OF SANTORINI

The island of Santorini sits in the Aegean Sea like some huge fractured bowl, its various pieces forming what's left of a once much larger volcanic island that exploded in prehistoric times.

These fragments circle the now ocean-filled caldera of the old volcano, their inner walls of rough and craggy lava rising precipitously out of the blue water—often hundreds and hundreds of feet!

Like me, I'm sure you've seen postcards or photos of Santorini and its principal town, Fira (Thira) sitting atop the cliffs. Postcards are one thing—but confronting the real thing is quite another!

My first visit to Santorini was aboard an airliner from Athens—a somewhat late evening arrival that literally left me in the dark. Exiting my hotel the next morning and seeing Fira, Santorini and the rest of the scene was truly overwhelming. An arresting and dramatic view at every turn.

The narrow little streets, the houses, shops, even churches, *all* seem to crowd toward the great volcanic cliffs—almost as if competing for the position of being closest to the very edge of the chasm!

Fira, like most Greek island towns, is composed of white-washed and pastel-colored buildings that, because of the jumbled geography, sit at every imaginable angle and level to each other (a nightmare for the artist who must draw it, and who may not really understand perspective!). All this, with the dark, multicolored lava cliffs, the blue sea far below, the sky stretching from horizon to horizon, creates a plethora of painting subjects. So many, in fact, that one of the biggest problems the plein-air painter faces here is being able to pick one, settle down and get to painting it!

MY PAINTING GOAL

Given all the great material mentioned above, my plan was to get to a spot where I could draw and paint, trying to incorporate the sky, the sea, the town and the cliffs in a dramatic composition that would speak of the very essence of Santorini!

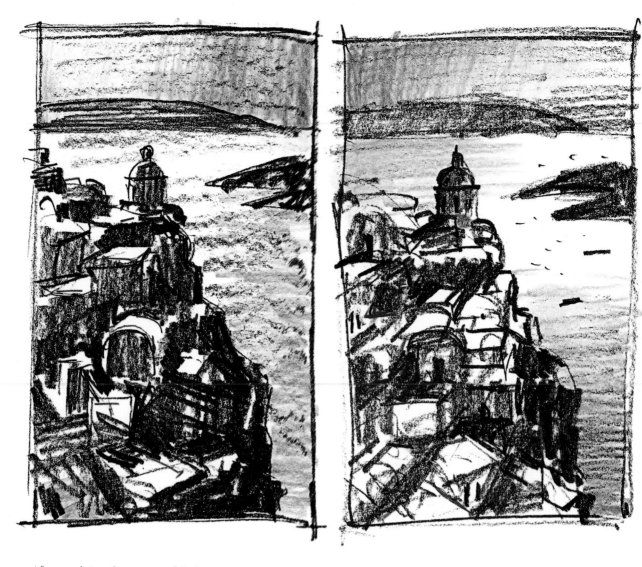

▲ After studying the scene, I felt that a vertical composition would be best for getting the feeling of that little town, perched atop the steep cliffs, with the ocean nearly straight down below it.

Except for reorganizing the jumble of the architecture and editing some parts, the composition of the scene was really quite good just as it was. So I made only one compositional/value study, but two versions of it: one with the morning light coming in from the left, the other with the afternoon light coming in from the right. Either one would be an exciting challenge to paint. I decided on the afternoon light. The afternoon sun, shining on and between the buildings, would "open up" the shadows with lots of reflected light and thus allow me to paint a higher key painting, something I enjoy doing. The glare of sunlight on the ocean turned out to be a dramatic asset.

▶ In my pencil drawing I tried to organize and edit the subject so that, though still having a crowded, busy feeling, it would be more readable and less confusing.

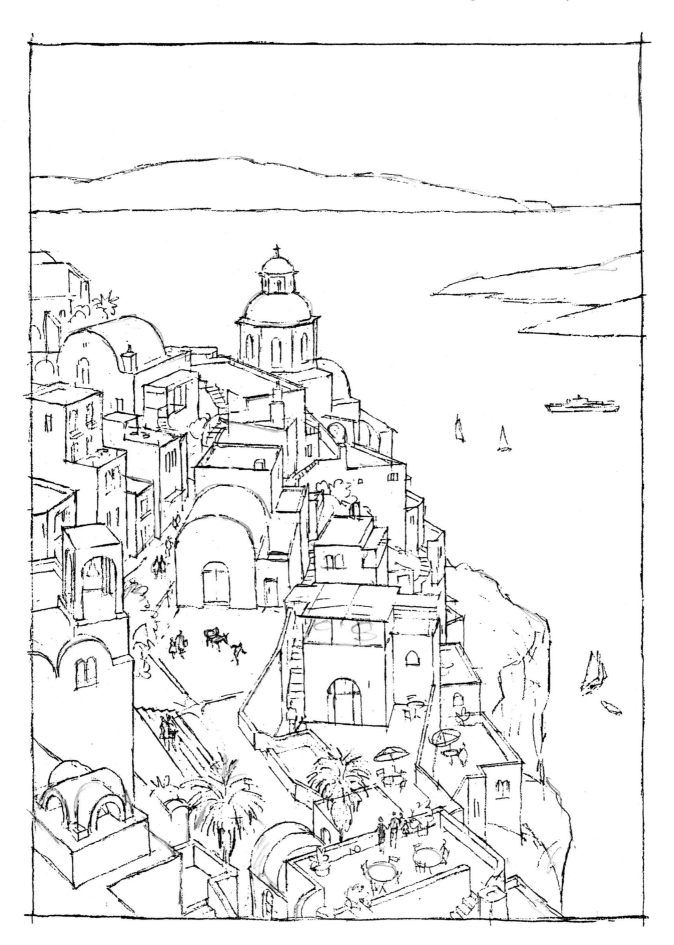

STEP ONE Painting the Greek Island of Santorini

▼Using masking tape, carefully cut, I shielded the edges of buildings and boats so that I could paint the ocean freely. Using 1½-inch and 1-inch flats, I did semi-dry drag strokes across the dry paper to get the effect of glare on the water. As I painted further down the ocean area, I made it wetter and charged richer pigment mixes into it. After removing the tape, I painted light-to-middle value shapes on the buildings.

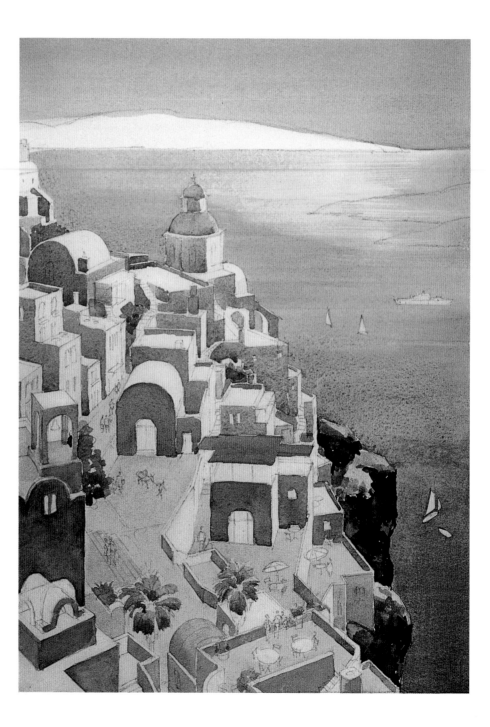

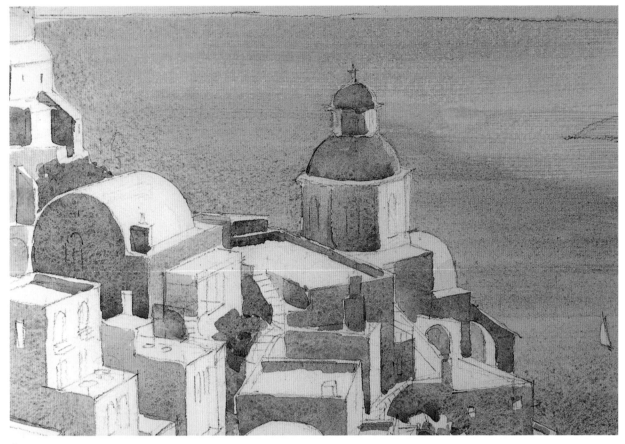

▲
▼ **DETAILS OF STEP ONE**

STEP TWO Painting the Greek Island of Santorini

▼ I continued the business of painting shapes—such as the distant hills across the water, then some of the dark and middle values of windows and doors, little flat areas of color and value for the umbrellas, tables, figures and vegetation. Most of this was done with my ⅝-inch flat brush, but I used the no. 6 round red sable brush for the figures. The enlarged details at right give a clear idea of how even little details can be kept simple—and thus avoid an overworked look.

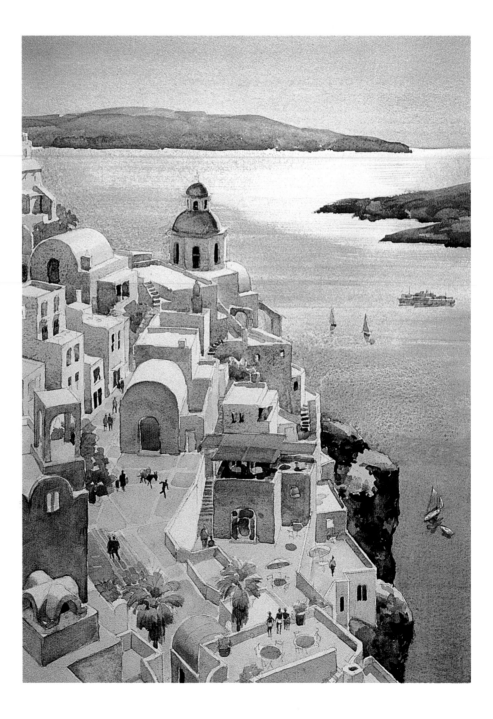

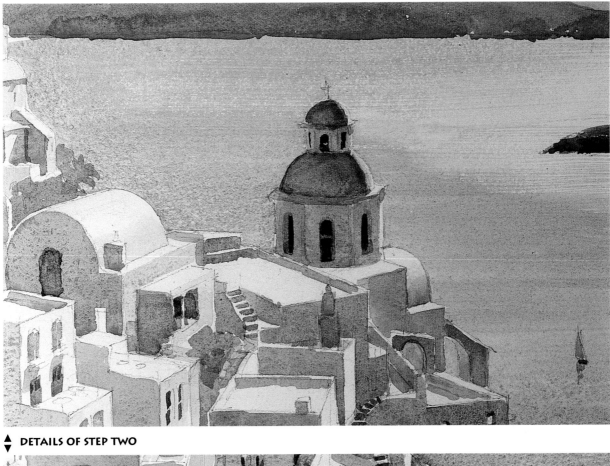

▲ DETAILS OF STEP TWO
▼

STEP THREE Painting the Greek Island of Santorini

▼About this point, I started painting the cast shadows, which added a lot of dimension. Note that cast shadows are often darker in value than the object that is casting them—especially if color and value is about the same in both areas.

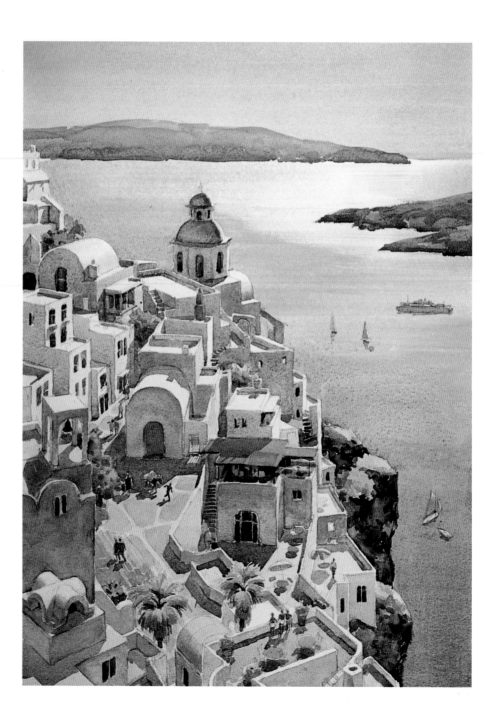

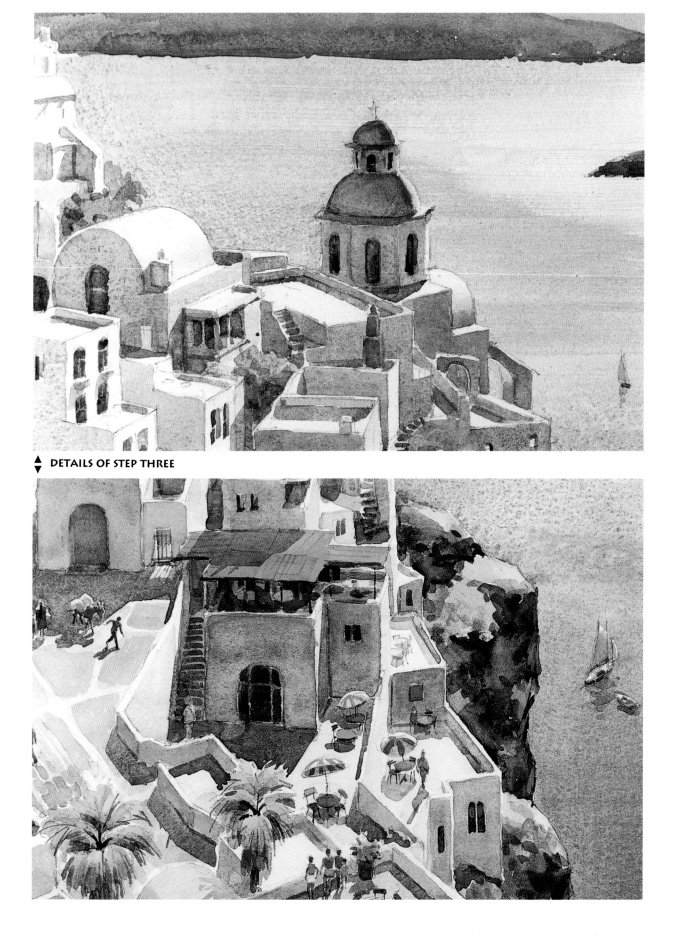

DETAILS OF STEP THREE

STEP FOUR Painting the Greek Island of Santorini

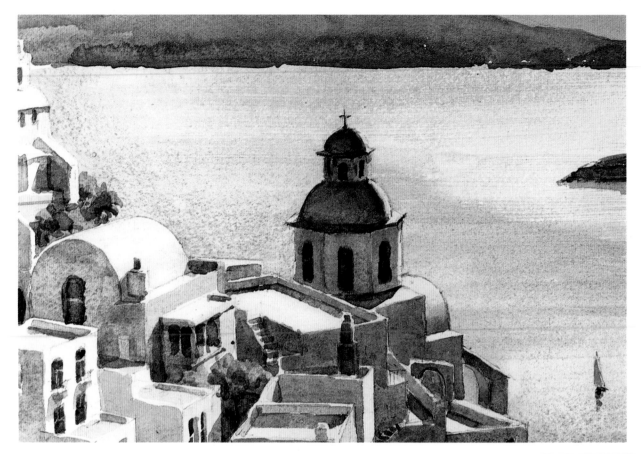

▲▼As is so often the case, the final work on a painting isn't much. If you've planned and executed your painting well, when you get to this stage about all there is to be done is add a detail or two, make a correction or two— then step back and see if you have achieved your painting goal.

▶ VIEW OF FIRA, SANTORINI 20″ × 14″

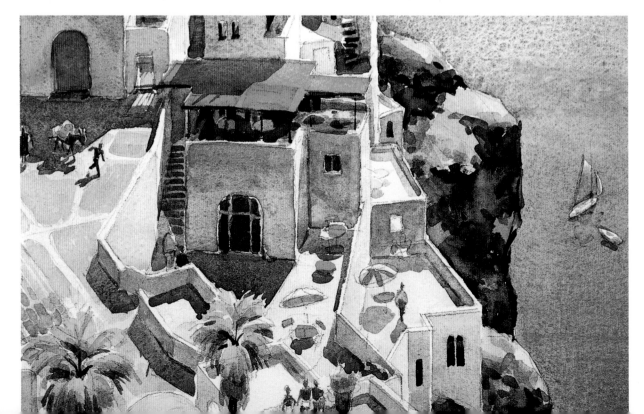

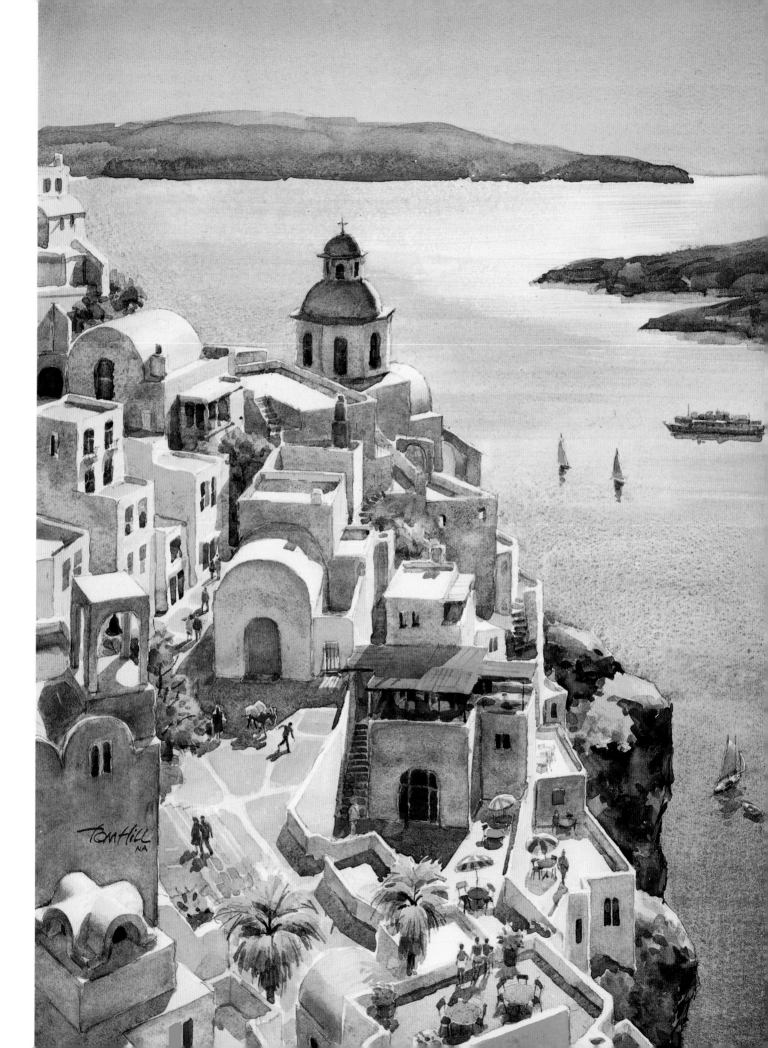

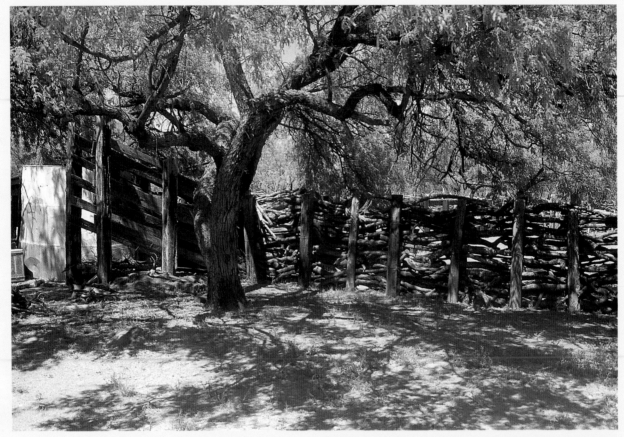

▲▼My painting subject is an old-time cattle-loading chute and mesquite-wood corral fence. The tree in front of the fence is mesquite also. Below is a drawing I made of the corral gate, so that I could understand its construction before I tried to paint it.

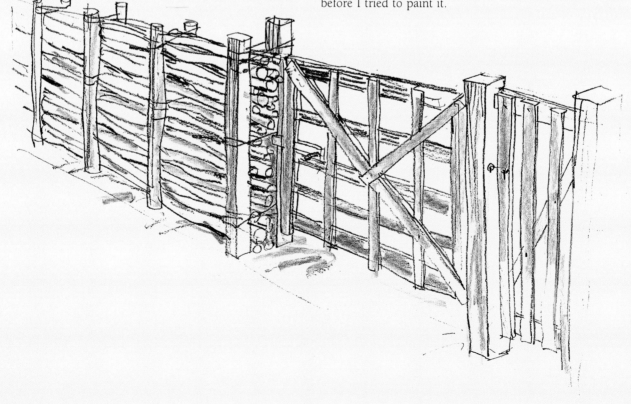

PAINTING AN OLD WESTERN CORRAL

Not far from where I live is an old ranch with several buildings, corrals, animal pens, etc. The oldest part of one of the buildings is made of adobe walls and probably dates back nearly a century. Although the cattle-loading chute (at left) isn't used anymore and is in need of repair, the corrals and gates are OK and are occasionally used to hold animals. Part of the corral fence is constructed in a unique fashion, not used much anymore and found mainly in the southwest and Mexico. Double fence posts are put in place, about eight or nine inches apart, and then branches (usually mesquite wood) are piled up within this space, until the correct height is reached. The whole construction is then wired tightly with baling wire. This makes a formidable-looking fence, and a terrific watercolor subject!

After obtaining the property owner's permission to paint on the premises, I set about finding a good way to interpret the scene in paint. I decided after making a study drawing of the gate (shown at left) that it would make a good visual lead into the composition, followed by the mesquite fence, trees, shed, etc. I also picked this view because I could paint in the shade of the ranch building and thus have both myself and my watercolor paper out of the direct sunlight. I find it difficult to judge colors and values when the paper is in the glare of the sun, and try to avoid such a situation.

I also thought it would be worthwhile to incorporate an animal somewhere in the picture, and though the corral was empty, I knew of a fine mare nearby, so I used her to add a bit of life to the painting. Remember how in chapter five we talked about using figures to give life and scale to paintings? An animal can serve the same purpose.

MY PAINTING GOAL

I set out to capture the feeling of warm sunshine filtered through an old corral fence and, hopefully, even suggest the dry and peaceful ambience of the setting.

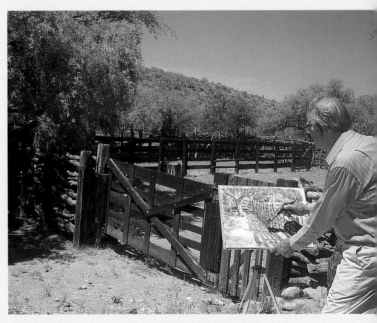

▲ The watercolor, about completed, was moved into the sunlight for this photograph. I actually painted from the shade of a ranch building behind me.

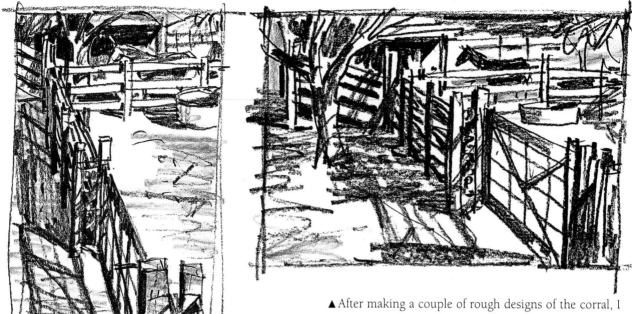

▲ After making a couple of rough designs of the corral, I opted for the horizontal one. I sketched the mare and her colt at a nearby ranch, and used those sketches as my reference for the horse in the painting.

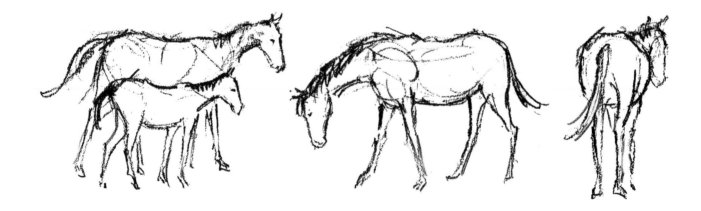

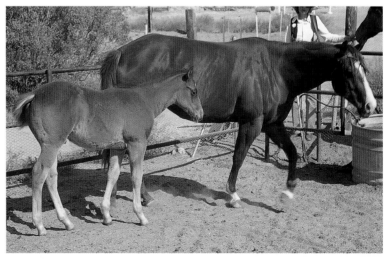

STEP ONE Painting an Old Western Corral

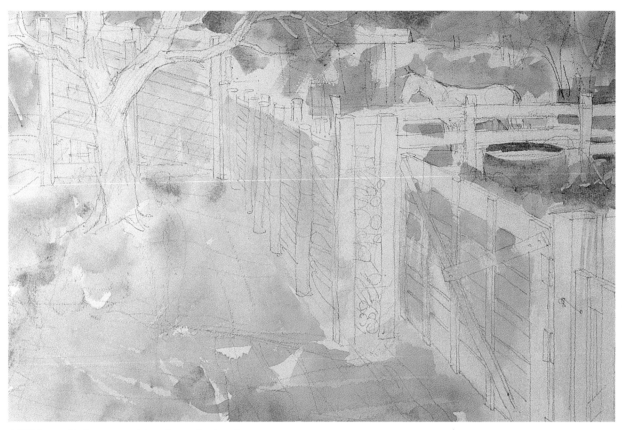

▲ With my little compositional rough sketch as a starter and guide, I carefully pencilled my design onto the water-color paper, making sure that my perspective was OK and that the drawing of the horse wasn't too large or too small for the setting.

I mixed light value washes of yellow-greens, blues and violets, which I painted on the top half of the paper in wet-in-wet fashion, and then tints of warm yellows and pinks for the foreground.

STEP TWO Painting an Old Western Corral

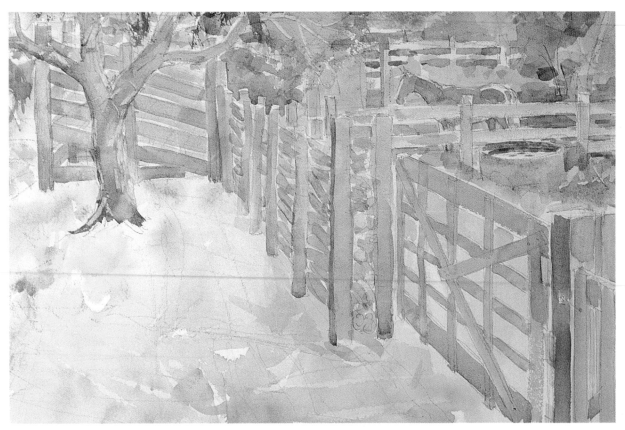

▲ I painted the tree and the corral using light-to-middle values of both warm and cool hues. These were mixed from Raw Sienna, Scarlet Lake, Cobalt and Manganese Blues—with just a bit of Burnt Sienna here and there. The two enlarged details on the facing page clearly show the simplicity of these washes and their application.

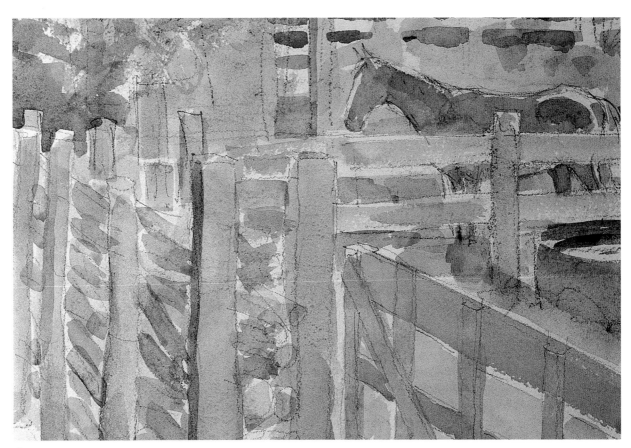

▲ **DETAILS OF STEP TWO**
▼

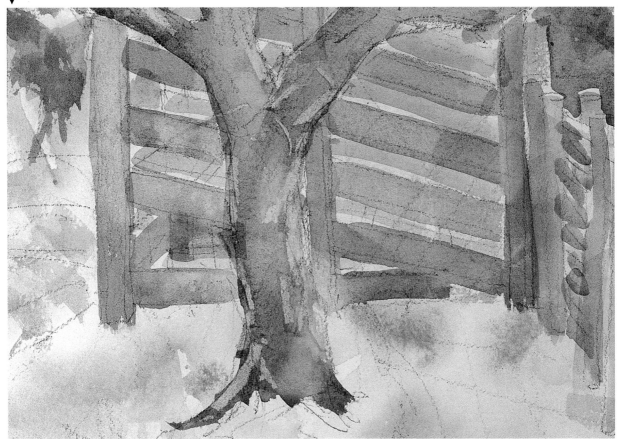

STEP THREE Painting an Old Western Corral

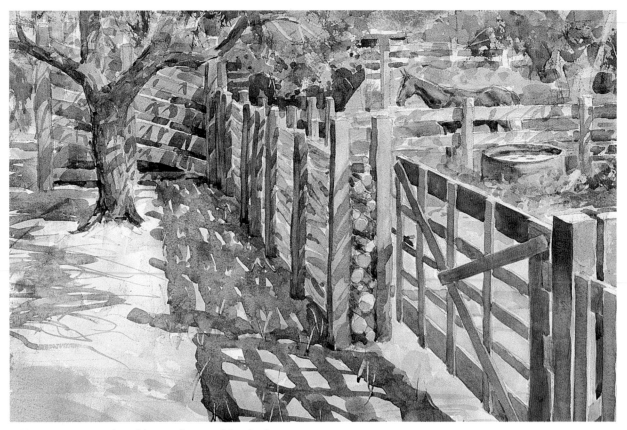

▲ Here you can see the addition of most of the shadows—both those *on* the objects and those cast *by* the objects. Although the cast shadows were basically cool in color temperature, I did charge warm hues into them. I observed very carefully how the sunshine filtered through the gaps between the mesquite logs in the fence, as well as how the shadow of the gate undulated as it fell across slightly uneven ground.

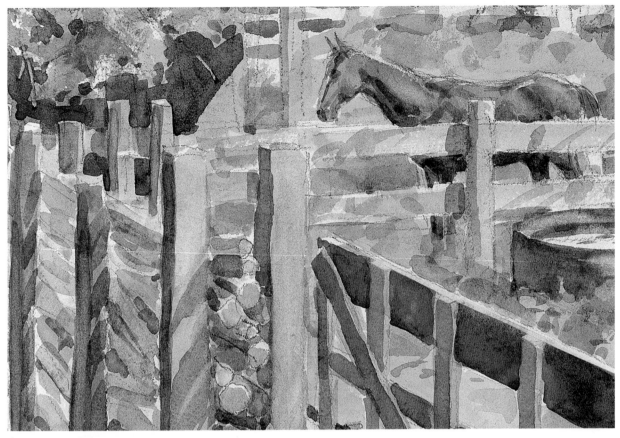

▲
▼ **DETAILS OF STEP THREE**

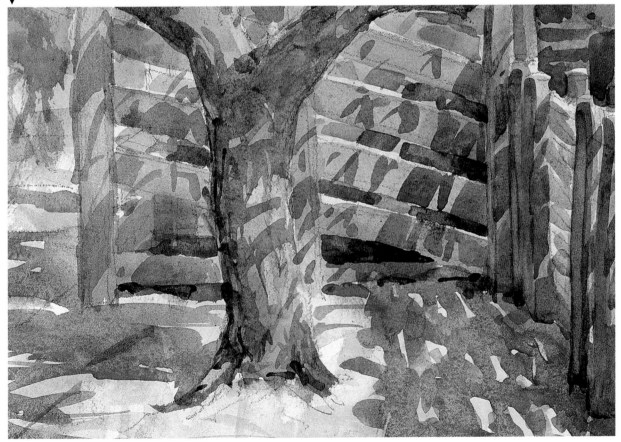

STEP FOUR Painting an Old Western Corral

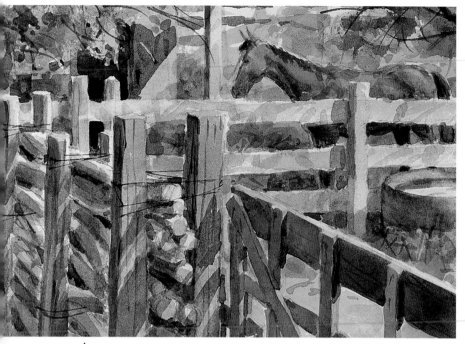

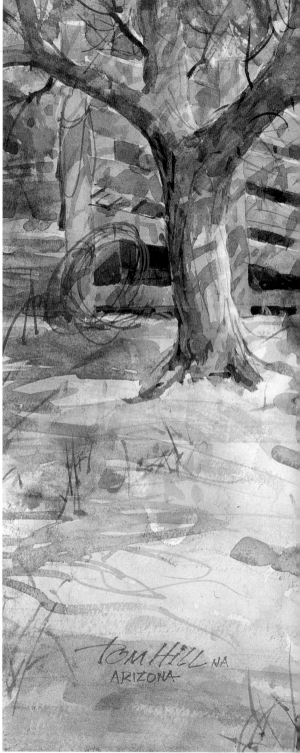

▲ **DETAILS OF STEP FOUR**

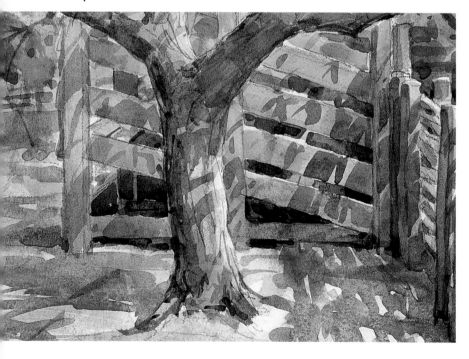

▲ OLD WESTERN CORRAL 13½" × 21"

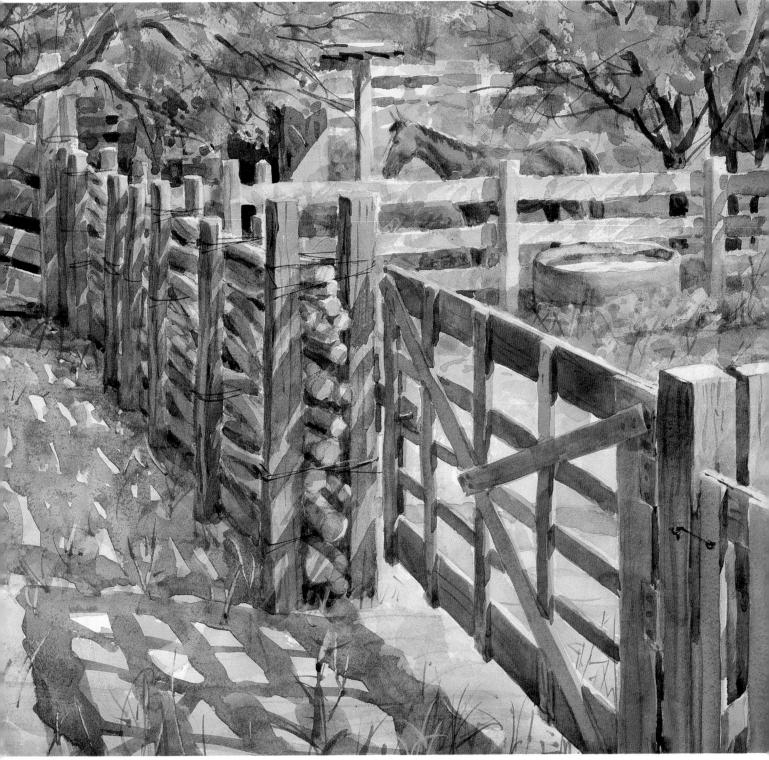

▲ At this point I darkened the shadow sides of the gate, fence posts and tree. I also went back and darkened areas in and around the loading chute and the shed. I finished painting the darks and details in the mesquite branches that make up the horizontal parts of the fence. The horse got a mane and tail. Smaller tree trunks and all smaller limbs were painted. Last, with a no. 6 rigger brush, I added the baling wire that holds the fence together, grass and wood textures, and even an old roll of barbed wire. That's enough!

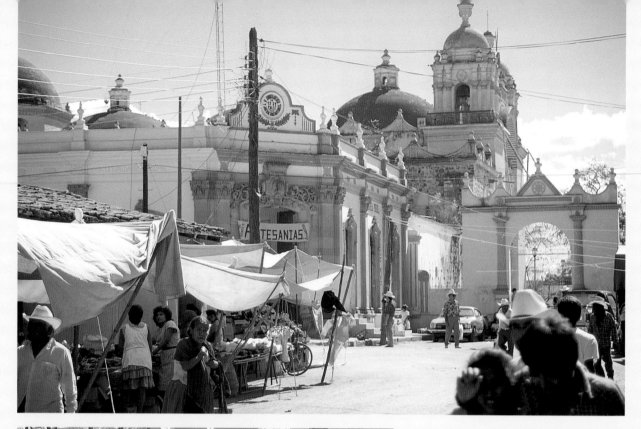

▲ Pay attention to your light source when painting on location, for it will change! I made my Ocotlán painting by morning light. The photo above was taken later in the day by afternoon light. An entirely different mood!

◀▼ These two photos give an idea of the market situation: crowded and busy, with an overwhelming variety of shapes, colors and textures to see.

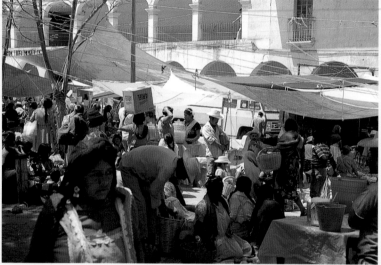

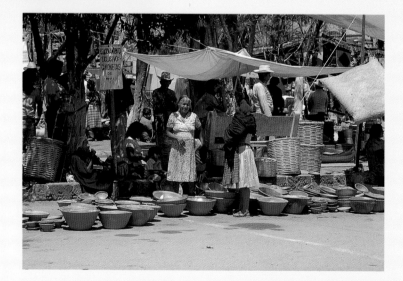

Chapter Twelve

PAINTING OCOTLÁN ON MARKET DAY

Perhaps you've never heard of Ocotlán. Most folks haven't and it's certainly not a tourist destination. In fact, getting to this town in southern Mexico isn't especially easy, but to me it's well worth the effort—for Ocotlán is a visual treat and a great source of very paintable subject matter.

Visiting this area is a little like going back in time. Burros and horses, wagons and oxcarts are common carriers, as are rickety old buses and all-purpose, flatbed trucks. Most of the inhabitants speak the Zapotec language, with Spanish as their second tongue, and many still dress in costumes particular to their own villages.

Once a week, folks from all the outlying farms and tiny villages come to Ocotlán to participate in the impressive open air market, centered at the town plaza. The entrepreneurial spirits run high, as do the impulses for social visiting—so the market usually fills up, overflowing the plaza area and extending out onto the nearby streets, even as far as the government buildings and the old colonial church, another block away!

On my last painting trip to Ocotlán, I was struck by the following scene: The sun was nearing noon, its brilliant light creating a glare on the pavement of the main street, just south of the plaza. The buildings, awnings, people, and goods for sale were all backlighted—even silhouetted—against the glare and all of this made a vivid and paintable impression on me.

Setting up an easel and trying to paint in the middle of a crowded, busy situation isn't usually a very practical idea (as I mentioned in chapter five, concerning the crowded market in Bali). In Ocotlán, I had a vehicle parked nearby, with essentially the same scene in view. So I was able to paint in a relatively comfortable way, have easy access to my subject and not be in the path of all the market activity. I kept my painting size small—about 9″ × 12″. I have been able to paint in busy situations like this, but always found everything was better if I positioned myself to one side—on the fringe, so to speak.

MY PAINTING GOAL

My painting goal was rather obvious: to catch that brief moment in time that I saw in Ocotlán and preserve it in a watercolor!

▲◄▼ These studies were done somewhat simply, striving mainly to capture basic shapes and gestures. Just by going through the process of looking hard and studying the figures' characteristics, I was better prepared to paint them with authority!

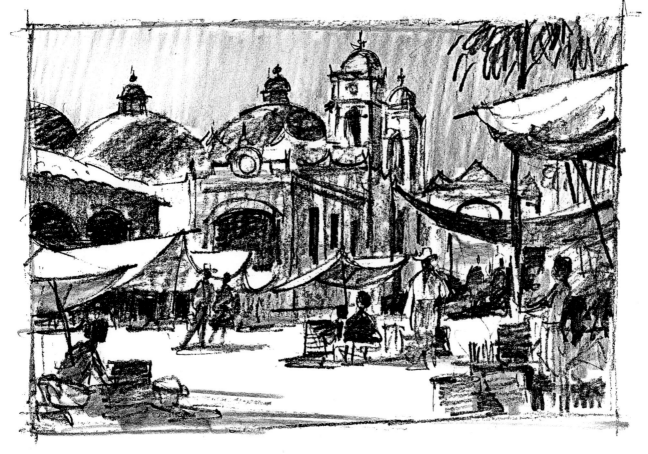

▲ I made just one compositional rough sketch because the scene before me practically fell into place—a comparative rarity in on-location subjects! All that was needed were a few editorial simplifications and changes to get a painting design that I felt good about.

▶ I made the diagram to the right of this sketch to demonstrate how even complex subjects, like the church in Ocotlán, are really only basic shapes underneath that ornate façade. Just as figures and animals in paintings can be constructed from basic shapes (chapter five), so can architecture. Look for boxes, spheres, circles, etc. Note: Circles become ellipses when seen from any angle other than straight on.

STEP ONE Painting Ocotlán on Market Day

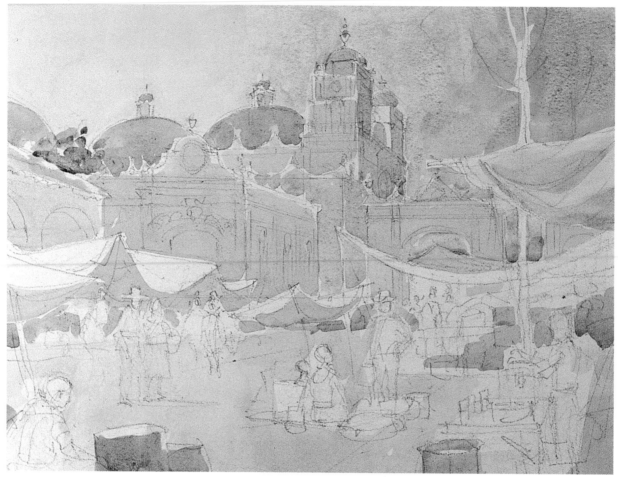

▲ My composition rough was transferred to my little (about 9″ × 12″) watercolor paper. Once I felt that the pencil stage was accurate enough and the design looked OK, I started painting, applying light-value washes with a ⅝-inch flat brush. In the detailed enlargements on the facing page, you can see that I was basically using yellows, reds and blues, some slightly grayed and all of them no more than tints of color.

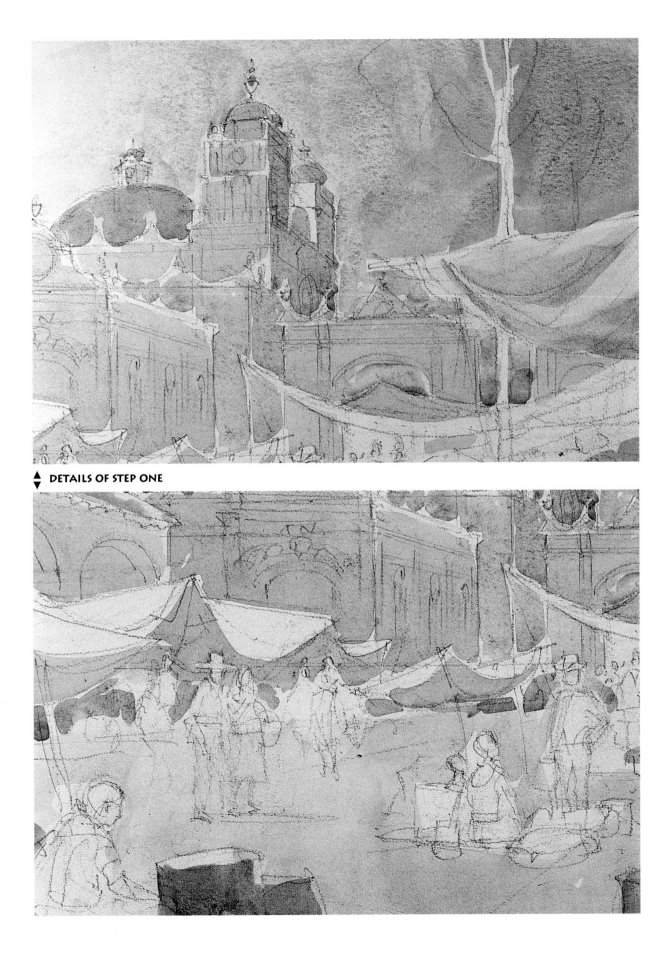

▲ **DETAILS OF STEP ONE**
▼

STEP TWO Painting Ocotlán on Market Day

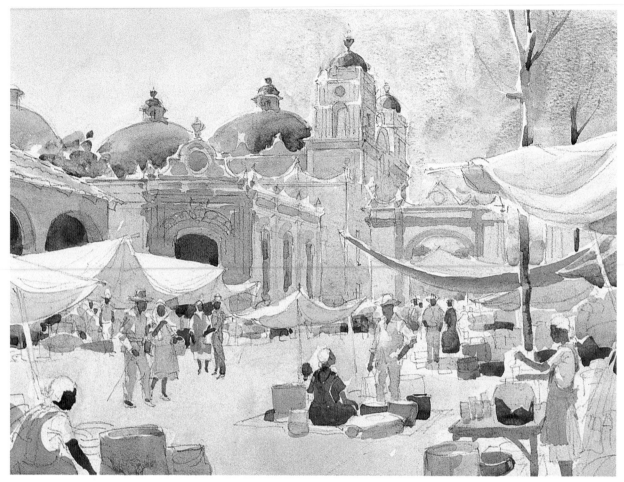

▲ At this stage of the painting I added the shapes of heads, arms and legs, using Burnt Sienna in varying intensities and values. I used a no. 6 round red sable brush, and avoided any detail. I also added some shadowed sides to buildings and awnings.

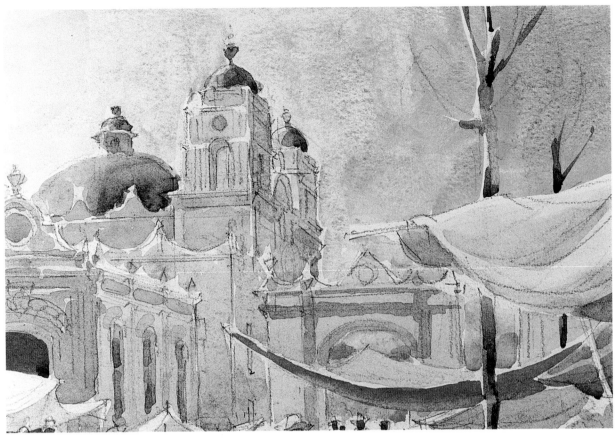

▲
▼ **DETAILS OF STEP TWO**

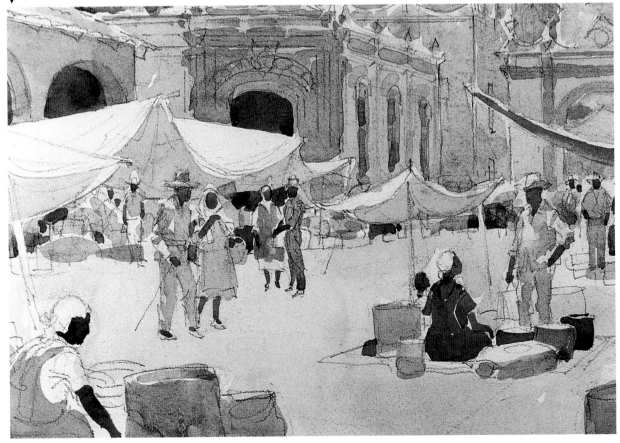

STEP THREE Painting Ocotlán on Market Day

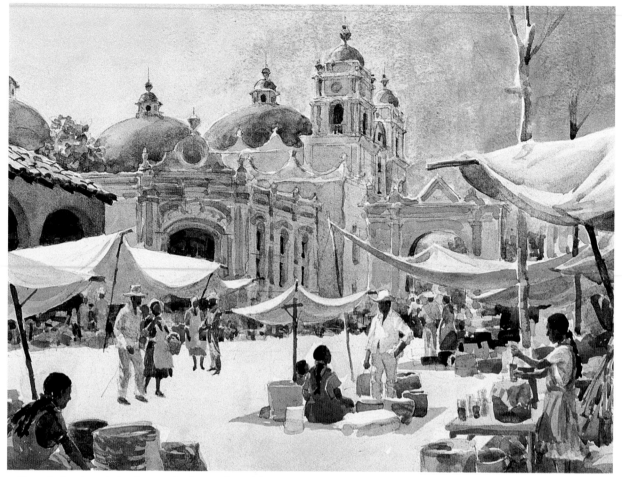

▲ Next, I developed the figures further. A lot of this was accomplished by how and where I painted the *shadows* on each figure—the detail at the bottom of the facing page shows this quite clearly. Then I realized parts of the buildings needed darkening, so I did that. I made sure that the "glare" on the street area was kept as one of the lightest areas in the composition.

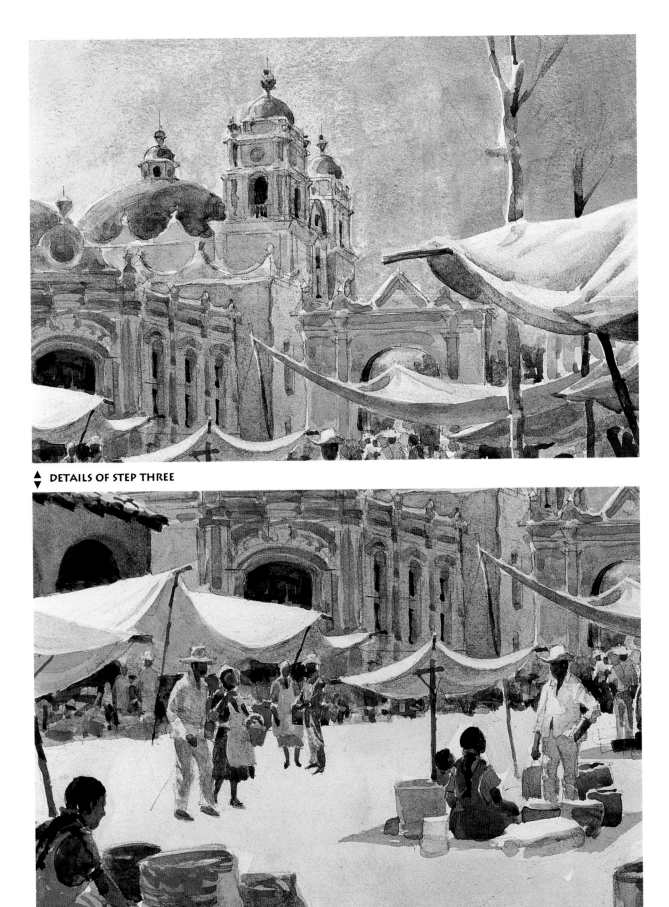

DETAILS OF STEP THREE

STEP FOUR Painting Ocotlán on Market Day

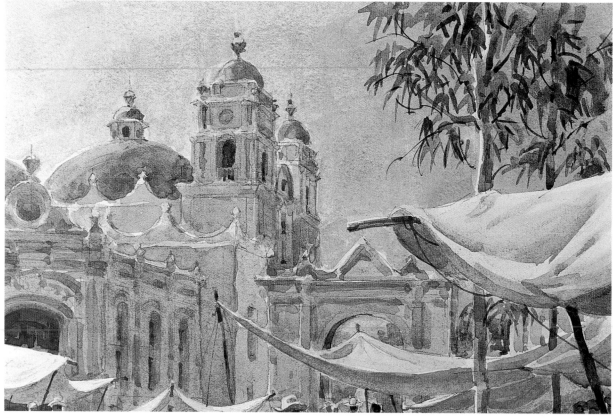

▲ **DETAILS OF STEP FOUR**
▼

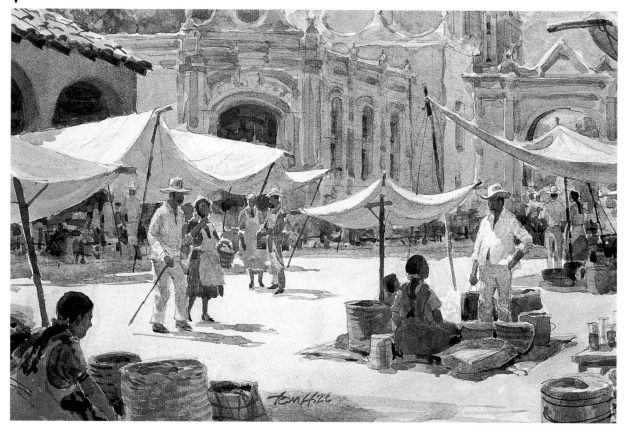

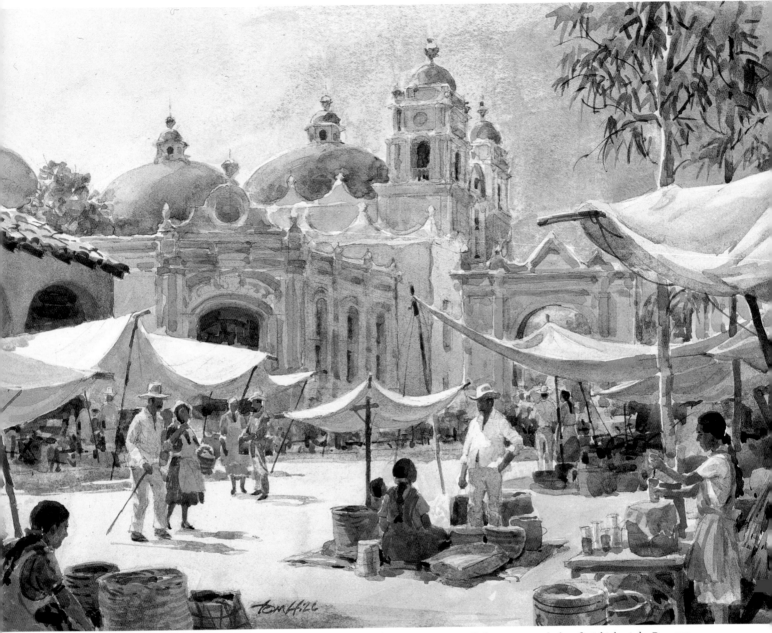

▲ At this point in the painting process, I added the cast shadows, a very important part of making the painting "read." These shadows tell us where the light is coming from, anchor the figures and other elements to the ground, and aid in getting the feeling of glare that I was impressed with in the first place! A few details and adjustments were all that was needed to finish the job. Remember, even so-called "details" are really only barely indicated—and act as "suggestions" for the viewer's eye, and the viewer's imagination.

MARKET DAY, OCOTLÁN 9″ × 12″

GALLERY

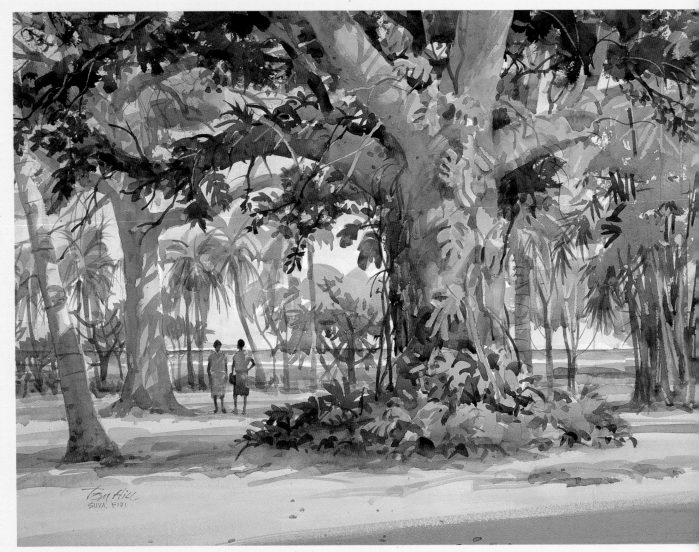

◀ Granada was a stronghold of the Moors until 1492 and many remnants of both Moorish and Spanish history are still there. These old buildings and narrow, cobbled lanes caught my imagination, and this painting strives to capture that brief moment when the noon sun glances down between the buildings, illuminating the street below.

OLD GRANADA, SPAIN 28″ × 21″

▲ The Fijians call this giant tropical tree a Silver Rain Tree—perhaps referring to the effect made by its blossoms when they fall. The old tree also nourished a great number of orchids and bromeliads which were rooted in its branches. A couple of handsome Fijian men happened to be passing through, dressed in their traditional skirts. I used them to help give scale, ambience and location to my picture. The Pacific Ocean, looking very pacific on that tropical, sunny morning, could be glimpsed through the trees and shrubs so I used it as another valuable element in setting the mood of a tropical scene.

SILVER RAIN TREE, SUVA, FIJI 21″ × 29″

▶ To visit the islands of Tahiti was a boyhood dream of mine. When I finally reached them a few years ago, I was a bit let down by Tahiti itself—small, expensive, touristy. But, the neighboring island of Moorea turned out to be more of a fulfillment of the old dream.

Though a rather small island, Moorea has jagged, volcanic peaks, deep valleys and bays; surf crashes on outer coral reefs, with calm, mirror-like lagoons within. All of this is laced with a profusion of tropical foliage and a certain sense of history—and mystery. Great painting material abounds at every turn!

I was staying at Cook's Bay and just out from the cottages lay the scene you see here. It needed only a little rearranging and editing to make a good composition that would help convey the mood of the place. I eliminated some of the foliage to make the middle and background planes more readable, borrowed the figures and outrigger canoes from an area to my left (out of the immediate scene), increased the size of the mountains and simplified the thatched-roof cottage. This painting was completed on location, as a class demonstration, and took about two hours to plan and execute.

▲ COOK'S BAY, MOOREA, TAHITI 17″ × 26″

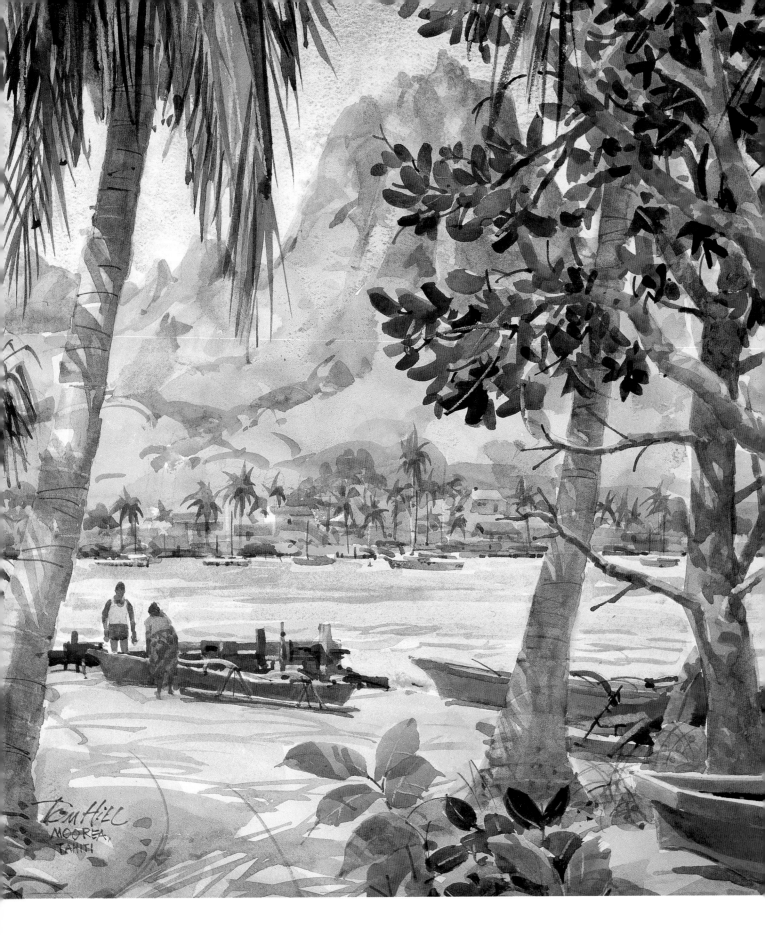

Tom Hill
MOOREA,
TAHITI

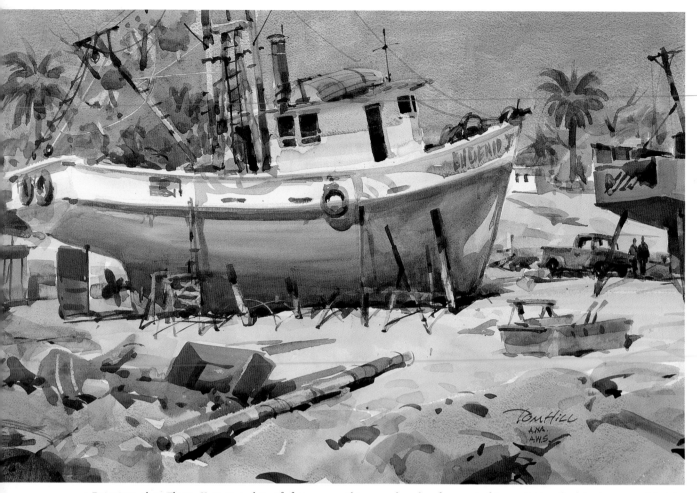

▲ Painting the *Elena II* was a lot of fun—everything seemed to fall right into place! The location was a small Mexican fishing village on the coast of the Gulf of California, where boats are towed up onto the beach for repair and refurbishing, I guess you could call it a "drydock" of sorts!

I found a neat old boat, somewhat the worse for wear, and situated myself in the morning shade of another boat nearby. I figured I had about an hour of shade before the sun would clear the top of the boat in back of me and shine directly on my watercolor paper. So, I set right to work, using one- and one-and-a-half-inch flat watercolor brushes for most of it—painting the big shapes and finishing with a few details done with small round watercolor brushes and a no. 6 rigger brush. The whole process took something less than an hour. But, I had the advantage of having made many such paintings over the years and have tried to learn from my past failures, and all of that helped me a lot in being able to "bring this one off" in so short a time.

ELENA II IN DRYDOCK 14″×21″